Bellamy's
BRIDE

D0871123

Bellamy's BRIDE

The Search for *Maria Hallett* *of Cape Cod*

KATHLEEN BRUNELLE

Charleston | London

THE
History
PRESS

Published by The History Press
Charleston, SC 29403
www.historypress.net
Copyright © 2010 by Kathleen Brunelle
All rights reserved

Cover image: *The Girl I Left Behind Me* (detail). Eastman Johnson. Smithsonian American Art Museum. Museum purchase made possible in part by Mrs. Alexander Hamilton Rice in memory of her husband and by Ralph Cross Johnson.

First published 2010
Manufactured in the United States

ISBN 978.1.59629.254.3

Brunelle, Kathleen.
Bellamy's bride : the search for Maria Hallett of Cape Cod / Kathleen Brunelle.
p. cm.
Includes bibliographical references.
ISBN 978-1-59629-254-3
1. Hallett, Maria. 2. Bellamy, Samuel, 1689-1717. 3. Bellamy, Samuel,
1689-1717--Relations with women. 4. Young women--Massachusetts--Cape Cod--
Biography. 5. Pirates--Massachusetts--Cape Cod--Biography. 6. Cape Cod (Mass.)--
Biography. 7. Cape Cod (Mass.)--History--18th century. 8. Shipwrecks--Massachusetts-
-Cape Cod--History--18th century. 9. Hallett, Maria--Legends. 10. Bellamy, Samuel,
1689-1717--Legends. I. Title.
F72.C3B84 2010
974.4'9202092--dc22
[B]
2010019858

Notice: The information in this book is true and complete to the best of our knowledge. It is offered without guarantee on the part of the author or The History Press. The author and The History Press disclaim all liability in connection with the use of this book.

To my husband, Robert, my prince.
To my son, Baylen, my joy.

Contents

Acknowledgements

I would like to thank the following people for their help in creating this book:

First of all, I would like to thank Barry Clifford for his unfailing belief in this marvelous old legend. I would also like to thank my commissioning editor, Jeffrey Saraceno, for his interest in this story and his guidance along the way; Paule Burkett, for first sharing Maria's story with me; my husband, for his support and expertise; my son, for his patience and encouragement; Kenneth Kinkor of the Whydah Museum, for his guidance and for answering my many emails; Charles and Janet Munro, for allowing me to use the beautiful painting of Sam Bellamy and Maria Hallett; Alison D'Amario, the director of education at the Salem Witch Museum, for her generous help; Marcella Curry at the Sturgis Library in Barnstable; Paul Cyr at the New Bedford Public Library Genealogy Room; the staff at the Barnstable County Probate Court; the staff at the Massachusetts Archives; Olivia Englehart, for her beautiful illustration of Maria; and all of my family and friends, for their support through this process. A special thanks to my brother, Robbie, for providing me with inspiration.

The Search

I grew up on a narrow strip of sand known as Cape Cod. My childhood was filled with summer cottages, sea glass, swimming lessons and penny candy. Most days, I rode my red ten-speed bike to the village of Cataumet, where I shucked lobsters and clams for winter locals and summer tourists alike.

We lived in an old saltbox-style house one block away from the beach. Pirates by day, my sister, brother and I would search for buried treasure in the marsh behind our home, carving makeshift and secret paths out of tall reeds and cattails.

Our house held treasures, too, though of a different sort than the rubies and silver coins that we imagined lay buried in the swamp outside our back door. On rainy afternoons, my sister and I crawled carefully into the eaves on either side of my little brother's second-floor bedroom, while he sat on the floor outside and maneuvered his great yellow dump trucks to and fro.

We lowered our backs and slowly entered the crawl space, for the roof was slanted and low. I always went first and waved my right hand into the darkness until I felt the familiar grooves of the plastic pull cord at the entrance and yanked it. The exposed light bulb blinked and then burned steadily, while my sister and I began our explorations. A blockade of Christmas decorations and worn-out shoes was hastily placed in the

opening. We made our way through golden garlands and pine cone trees, strands of glittering tinsel littering our hair. Once we pushed past the family storage and moved along the perimeter of the house, a time portal awaited, beyond which were dishes and dresses from the century before when the house was first built. And beyond the cobalt glasses and white cotton gowns was the best treasure of all—books upon books, in random stacks of various colors and bindings.

With the entry light to the eaves a world away, the books appeared even older and more mysterious in the dimly lit reach of the crawl space. I felt the covers, rough and dimpled with age, and chose only one at a time. With the largest book in hand, I made my way carefully back through the eaves and into my room, where I hopped onto my bed with my newfound treasure.

The faded covers were laced with powdery dust so that when I opened each book, layers of the grayish soot sprinkled the air around me. The pages were yellowed, thick and full of stories from days long gone. Days of hurricanes that greedily wrenched our shore and swallowed our homes. Days of horrible parades and tearooms. Days of warships that littered our small harbor. These were books of gods and adventures and philosophy.

On those rainy afternoons, safe on the pink Holly Hobbie patchwork quilt my mother had sewn, I discovered my love for old stories. The children, ladies and soldiers about whom I read had once stepped where I stepped. They, too, loved and respected the beautiful seashore at the end of my street. They knew its steady roar and familiar cadence. And I realized that these people continued to exist as long as their stories survived. Some of the stories were obviously fictitious, and some I imagined were true, but most contained a little fancy and a little fact; I found those were the best stories of all.

My favorite tale, though, did not come from the dusty books in our eaves. Like any Cape Cod story worth its salt, it was passed on from generation to generation. One day, my mother's childhood friend, Paule, said that she had a tale for me—a magical Cape legend of pirates and storms and lost love. As the rain pelted the window on a raw day in November, we sat by her kerosene stove. While we held deep brown ceramic mugs of steaming tea in our hands, she recounted the story of the dashing pirate, Sam Bellamy; his beautiful young love, Maria Hallett;

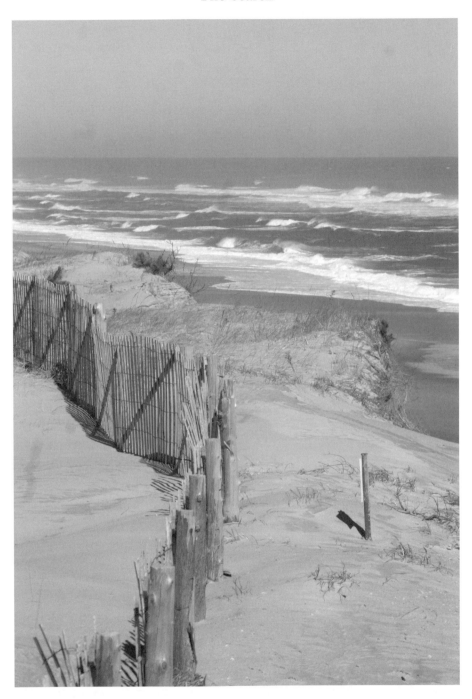

Wellfleet Dune View. *Photo by the author.*

and the fateful storm in April 1717 on the shores of present-day Wellfleet that separated them forever.

Years passed, and the haunting story of the *Whydah* made the local and then national headlines when a fellow Cape Codder named Barry Clifford searched for and discovered the wreck of the great pirate ship. He, too, had heard the wondrous tale, from his uncle Bill, and he never forgot it, either. Instead, he sifted through old maps to pinpoint the resting place of the old pirate galley. Clifford found evidence of the *Whydah*, but more importantly, he taught us that if we really believed, even in legends, they could come true.

The fanciful and historical tale of the *Whydah* has never left me. Its characters and tragedy tugged at me for years, especially since I began to write stories as much as I read them. Not long after the *Whydah* was discovered and its belly was finally raised from the depths of the Atlantic, I revisited the old story.

The pirate Samuel Bellamy was a real man, and his exploits had been documented by Kenneth Kinkor, the historian at the Whydah Museum, which was established to house Clifford's finds. After all of the new research and evidence, however, one piece of the story has yet to enter the realm of reality. The pirate's young lover—the beautiful girl from Eastham—remains a footnote to the famous tale. Kinkor had researched local records and found promising leads, but no one knew the young girl's identity for sure, nor did anyone know what happened to her after her pirate lover went down with his galley that fateful night three centuries ago.

In the time that I have spent poring over various versions of the legend and researching genealogy records and court documents, I realized a universal truth about folklore. Some of it is always based in fact, and most of it is created over generations of time. The beauty of these stories, however, rests in their mixture of the latter elements. I came to understand that Maria Hallett, factual or fictitious, is still an important part of Cape Cod history. Her story, like many other old Cape stories, represents the beliefs and struggles of our people as they explored a new land. Like the legends represented in the worn and dusty books in my childhood home, Maria's legend is an important part of our folklore that needs to be preserved. Her tale—some of it truth and some of it fancy— begins on a warm spring day in 1715.

A Chance Encounter

N o one knows for sure the circumstances that led to Sam Bellamy and Maria Hallett's first encounter; in fact, there is little evidence to suggest that they met at all. Cape Codders, however, have never been bound by evidence. They are bound by the sea, and they are bound by its stories. According to Cape lore, the tale of the witch and the pirate, firmly entrenched in the waters off Wellfleet, began on a fateful spring day in 1715.

That was the day that young Maria Hallett, a Cape Cod girl on the verge of womanhood, met the bold and daring Englishman Samuel Bellamy. She would later be called a powerful witch by the village people who reared her, and he would become an infamous pirate who plundered scores of ships. But on that day, almost three hundred years ago, they were still two young people about to fall in love.

Maria Hallett was but a girl of no more than fifteen or sixteen years of age; however, rumors of her beauty stretched the long arm of the Cape. According to legend, her yellow hair was said to "glisten like cornsilk at suncoming." And her eyes—the eyes into which many hopeful young men would gaze—were as yellow as her hair or as blue as the deeps of Gull Pond, depending on whom you asked.

Samuel Bellamy was a man in his mid-twenties when he left England to stay with relatives on Cape Cod. He wore his black hair long and eschewed

the powdered wigs of the day. With a rugged face and chiseled features, he confidently walked through the village of Eastham. Townspeople said that he left a wife and child back in England, but no one knew for sure. He spent much of his time at the tavern owned by his relatives and would have had little reason to mingle with Maria.

While much has been written of Maria's well-to-do upbringing, very little has been recorded about her origins. Though we assume she lived on Cape Cod in the early eighteenth century, we do not know the name of the village in which she lived or even if she was born on Cape Cod. Some believe that she was the daughter of John Hallett, a successful Yarmouth farmer. Others believe that she was related to the Knowles family of Eastham. Still others say that she was born farther down the Cape and came to live with relatives in Eastham. One of the more outlandish theories contends that Maria was the daughter of a Salem witch hanged during the infamous trials of 1692. They say that after her mother's death, Maria left Salem and relocated to Eastham in order to stay with relatives. Most people, however, believe that Maria's parents were respectable farmers who hailed from the Yarmouth area.

Tales of Maria's personality are more consistent. In a place where a man could be charged for sailing his vessel on Sundays, Maria felt confined and sheltered. If her parents were indeed well-to-do, and their daughter was as alluring as the legends suggest, they surely anticipated a prosperous match for Maria. As independent as she was beautiful, Maria no doubt charmed the local boys. Indeed, Maria's father would have been a very nervous man and would have had good reason to be. By all accounts, though, Maria found the local boys disappointing and dull. Maria yearned for an interruption to the drudgery of eighteenth-century Cape life. No doubt she would have been intrigued by the sailors who strode in and out of Wellfleet; as a fifteen-year-old and a respectable girl, however, she would not have been privy to their tavern outings. Instead, she wandered the orchard by the Old Eastham burying ground and dreamed of foreign lands and ocean adventures.

Young Sam Bellamy sought adventure, as well. Almost ten years older than Maria, he searched for his independence on the shifting shores of the Cape. While legends state that Bellamy came from the West Country in England, researchers now believe that they have pinpointed Bellamy's

birthplace as Hittisleigh near Plymouth in Devonshire, England. Legends state, and records now confirm, that the woman believed to be Bellamy's mother, Elizabeth (Pain) Bellamy, died shortly after his birth in 1689. They surmise that Bellamy spent much of his childhood with his siblings on the streets of Plymouth in England.

As a teenager, Bellamy undoubtedly sought the sea. As a privateer or part of the Royal Navy, Bellamy learned the skills that would make him one of the most daring and feared pirates of his day. By all accounts, Bellamy came from the lower rungs of society; he probably tired of his life as an enlisted man and came to the colonies to begin a new life after the war. His relatives had already settled in Eastham, and about 1714, he joined them. Spending his time at the tavern on the secluded bluffs of Great Island, he drank Sandwich ale through the cold winter evenings.

Situated across from Wellfleet Bay, the bustling tavern serviced fishermen, whalers, traders and farmers. More than one family was affiliated with the tavern, and Bellamy's relatives were among them. Within its planked walls and lead windows, sailors shared stories of their adventures and lives. The old-timers puffed on blackened pipes, which fell elegantly from their bottom lips and added a soft glow to the dimly lit tavern. And as this motley crew of men recounted raucous stories of sea and home, Bellamy dreamed of a better life, one in which he would be his own master.

Old Cape Codders say that one day in May of that year, or perhaps it was June, as Bellamy reclined in an obscure corner of Higgins Tavern, another popular Eastham tavern, he gazed eastward toward the orchard meadow. There, concealed only by the scant windowpanes from which Bellamy viewed her, was Maria Hallett. Her flaxen hair shimmered in the morning light as she rested beneath an apple tree. In that Cape Cod tavern, while his morning cider and cornmeal cooled, Bellamy fell instantly and tragically in love with the girl. Like Helen of Troy, Maria was the "fairest in the land" and held the apple to prove it.

There are those who will tell you that Sam never laid eyes on Maria until he came across her on a cool Cape evening. Perhaps he did not fall in love from the confines of a tavern window at all. Perhaps he exited the tavern one evening to clear his head of its "codfish and ale." Under the aegis of moonlight, he wandered through Judgment Lot and sought nature's solitude.

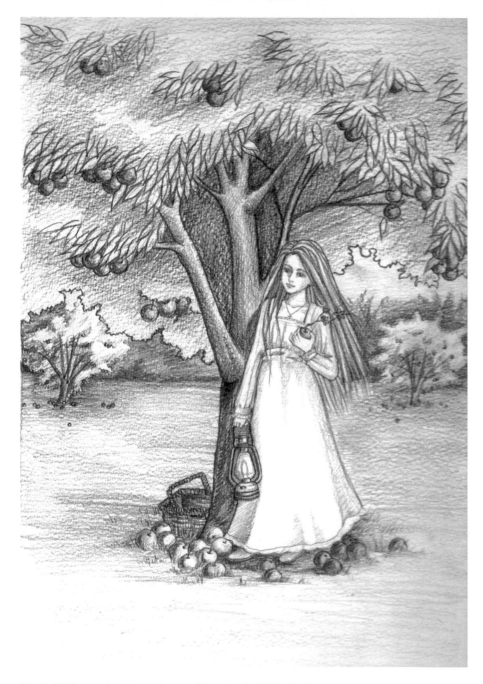

Maria Hallett under the apple tree. *Illustration by Olivia Englehart.*

Not long after he reached the southern end of his walk, Bellamy heard angelic singing. He followed the melody to a clearing in the woods. To Bellamy's surprise, a white cloud appeared in the hollow. Making his way through Tarnity Briars, Sam navigated the slope and discovered that what had appeared to be a cloud was really an apple tree, and under that apple tree was the most enchanting girl he had ever encountered. A streak of moonlight danced on her yellow hair and outlined her graceful silhouette. She raised her deep blue eyes, deep as the freshwater ponds that surrounded them, and continued to bewitch Bellamy with her song.

Still others say that Sam never left the tavern that evening at all. Rather, he fell into a drunken slumber and awoke with a cloudy head. In need of fresh air and clarity, Bellamy took to the orchard after sunrise. Only then, in the clear light of day, as he passed the cemetery in Wellfleet or the Old Eastham burying ground, did he find the young girl resting under the apple tree. Both the tree and the girl were in full bloom, and the white apple blossoms enveloped the innocent Maria. Each petal whipped vigorously around Maria's skirt until she was surrounded. Her hair, which had been pinned neatly beneath a white coif only moments before, danced beyond her temples in wild patterns. She could see her cool straw hat tumbling along gaily toward the graveyard. Enveloped in her own blonde strands and apple blossoms, Maria appeared like an enchantress in the middle of a spell.

Sam rounded the corner of the tree at the height of Maria's transformation. She felt his gaze upon her and looked directly into it. Holding "a drip-rush lanthorn in one hand and blossoms in the other," she met Bellamy's blue eyes with her own. Most say that they fell instantly in love. Bellamy was the first to speak. With his long black curls and determined stare, he introduced himself.

The two talked as if they had known each other for years instead of moments. Sam told Maria of his mother's untimely death, of his poverty and of the bustling streets of Plymouth. He told her of the queen and how he had gone to sea as a young lad to work in her merchant fleet. He spoke of Spain and war and kingdoms and navies. And lastly, he told her of his arrival in Eastham and his plans in this New World. As he paused, Maria noticed that his eyes spoke, too, but of a glory that raged and filled Maria with life. She could see that Bellamy moved like an elegant ship.

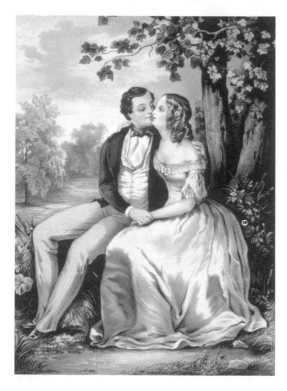

The Lovers. Library of Congress.

His breeches were tattered, and the bows that should have fastened them had long since worn away. But there was something about the way his dark hair was tied against the base of his neck, and something about his loosefitting shirt as it billowed, that commanded Maria's attention.

She was enchanted by Sam's stories of the sea and the proud manner with which he carried himself. She knew by his hardened appearance that he was not wealthy, but she was intrigued by this man who carried "his fortune in his three-cornered pocket, and mighty dreams in his eye." Maria had been waiting for a man like Bellamy—one who was worldly, self-assured and driven.

According to the legend told by Elizabeth Reynard in her 1934 book *The Narrow Land*, Sam acted quickly on his attraction to Maria: "Black Bellamy made masterful love, sailorman love that remembers how a following wind falls short and makes way while it blows." Like the spring blossoms in her hands, Maria was full of virginity and youth; Sam, tempted by her overwhelming beauty, seduced her in the cover of the orchard.

The earthen floor was their paradise, and the graveyard beyond was the world into which they would be cast out to fend for themselves and their love. She, a prosperous girl from a well-to-do family in the new land, and he, a poor man from the bottom of English society, submitted to each other that day under the apple tree. Their attraction was instantaneous and unmistakable. And so the story of the witch and the pirate begins here in an old Cape apple orchard in the spring of 1715.

Golden Dreams

W hile the idea of love at first sight is certainly romantic, the reality of a one-night stand is certainly not. And while no one denies that Sam and Maria consummated their love on the day they met, few can agree on what happened after that first encounter.

Many assume that Sam, a man who would one day become an infamous pirate, simply saw a golden treasure and boarded her ship, with little care or concern for the girl herself. They say, too, that he ruined her and took advantage of her naïveté and beauty, which could very well be true.

Most people forget, though, that in the eighteenth century other young couples had affairs prior to marriage. Weddings were often the byproduct of pregnancies, whether the husband-to-be was the father of the child or not. And Maria, from all accounts, was not an innocent and naïve girl. She was an adventurous and independent spirit who would not simply give her maidenhead to the first sailor to arrive in Eastham. No, Maria most certainly saw something different in Sam. Much like Hester Prynne in *The Scarlet Letter*, Maria made a decision on the day she met Bellamy.

Kinder tales of their meeting assert that Bellamy, too, made a commitment. Elizabeth Reynard paints a softer picture of a man turned pirate due to a promise—a promise made out of love:

Love was settled between them in no time at all, under the apple tree by the Burying Acre, and Sam sailed away with a promise to Maria that when he returned he would wed her by ring to the words of the Rev. Mr. Treat, and in a sloop laden with treasure, carry her back to the Spanish Indies, there to be made princess of a Western Isle.

But how was Sam, a poor English sailor, to keep such a lofty promise? Were these the drunken murmurs of a man before he set sail or the honest whispers of a man in love? It all depends on when he set sail.

Bellamy, like many other hopeful young men of his day, had heard of the Spanish Plate Fleet disaster. A fleet of about a dozen ships carrying countless chests of silver and golden coins and bars, emeralds, pearls and even Chinese porcelain encountered a massive hurricane off the coast of Florida en route to Spain from Havana. Spain traditionally removed treasure from its colonies to ease its troubled financial state at home. The Plate Fleet, however, had been detained in Cuba and set sail late into the hurricane season, thereby heading straight into ruin. Some of the ships broke up near the shore, while others were swallowed by the sea. A massive treasure littered the ocean floor, some of it in shallow waters. News of the disaster traveled not only to Spain but to other countries as well. Some say, in fact, that Bellamy knew of the Plate Fleet ruin when he came to Cape Cod.

Regardless, young Bellamy realized that this disaster—though a great loss to the Spanish—was the chance for which he had been hoping—the chance to break free from the bottom rungs of society and salvage a brighter future for himself if he could just salvage the treasure waiting in the shallow waters off Florida's coast. Bellamy also realized that he needed a ship, and he needed one fast. Other men were already chasing their dreams in those tropical waters, and Sam would be left behind unless he could get there quickly. Penniless, Sam paced the Great Island Tavern with big stories and bigger dreams.

Sam's supposed relative through marriage, Israel Cole, sat with the other men at the tavern and discussed the Plate Fleet disaster. Cole was no stranger to taking what belonged to other men. The Great Island Tavern, secluded and difficult to access, was also a warehouse at which black market goods were bought and sold. Because most of these items

The Great Island Tavern site in Wellfleet. The tavern no longer stands, but the land is preserved by the National Seashore. *Photo by the author.*

were from England, his trade was more honorable. According to Barry Clifford, the man who discovered the *Whydah* wreck and the author of the book *Expedition Whydah*,

> *Although many of the goods the smugglers fenced were stolen, most of them were probably stolen from British sources, which, given the attitude toward England, made it a far lesser crime, than theft from a neighbor. By the same token, goods smuggled in on ships might not have been stolen, but their sale evaded taxation.*

One of the men who frequented Cole's tavern was Paulsgrave Williams. He was visiting relatives on the Cape when he met Sam Bellamy. The son of a Rhode Island attorney general, Williams was a middle-aged jeweler with a wife and two small children. He was wealthy enough and had the means to procure a ship. While he didn't fit the stereotype of the typical penniless sailor, he understood the possibilities of the situation in Florida. There were millions of pesos said to litter the sandbars. As Barry Clifford

notes, "All a treasure hunter would have to do was snag one casket of coins and he would be rich beyond his dreams."

Williams, too, was a complex man and came from a respectable and noble parentage but who probably mingled with the likes of Captain Kidd. As noted by Colin Woodard in his book *The Republic of Pirates*, Paulsgrave's father died when he was only eleven. His mother remarried a Scottish exile, and his sisters married the associates of pirates and buccaneers. Paulsgrave Williams was as serious as Sam Bellamy about heading south that fall.

The unlikely pair forged an agreement: Paulsgrave would furnish a sloop, but he would sail with Bellamy. They planned the trip and assembled a crew of about twelve men over the course of a few weeks. Most legends assert that it was during these days of waiting that Sam met Maria Hallett. If so, he would have had good reason to believe that he could provide for the girl. But was she the only one for whom he needed to provide?

In most of the legends, Sam leaves Maria immediately after their tryst. However, some legends assert, and Barry Clifford agrees, that Maria and

View from the Great Island Tavern. *Photo by the author.*

Sam were inseparable after their first meeting. Clifford imagines that Maria, too, became a regular at the tavern on Great Island and helped Sam and Cole with the day-to-day business of smuggling goods. From the descriptions of Maria's lively and adventurous spirit, she would certainly have found excitement in the escapades at the tavern.

Maria's parents, of course, were not excited by the prospect of their daughter's union with a poor sailor. While they probably liked Sam, they did not believe that he could provide her with material comforts. Such men went to sea for long periods of time with little to show for their efforts, and they feared that Maria would be lonely and poor as well. Sam wanted to show them that he could not only take care of Maria but also that he was worthy of her.

The more time the young pair spent together, the higher the chance that Maria would become pregnant. And while one of the most important parts of the legend is Maria's pregnancy, many wonder if Sam knew of his impending fatherhood before he set sail.

The Plate Fleet disaster occurred on July 31, 1715. Even with the speed at which the news of the disaster traveled, Sam would have learned of the massive wreck in August. In most legends, he was said to have met Maria in the spring. Even if they did meet midsummer, Sam still

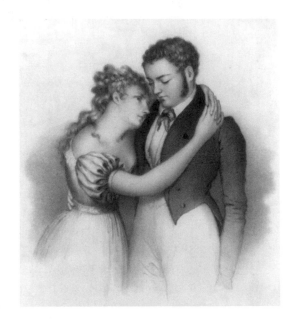

The First Parting. Library of Congress.

The Girl I Left Behind Me, Eastman Johnson. *Smithsonian American Art Museum.*

needed time to procure a ship and create a plan before he left Eastham for Florida. These dates certainly allow the couple to spend more than one night together. Most probably, Sam knew of Maria's pregnancy.

The news of the pregnancy would have provided even more of an impetus for Sam to chase and secure treasure. How was he, a lowly

seaman, to provide for a wife and child otherwise? Bellamy told Maria that he would return to her in a matter of months. Confident that he would leave his poor English upbringing behind to amass wealth and prestige, Bellamy filled Maria with hope and excitement. They would only need to be patient for a matter of months, he told her, and then he would return to her with a "ship full of gold." Some say that it was then, when Sam learned of the pregnancy, that he approached Paulsgrave Williams and convinced the jeweler to bankroll the expedition south. Those who believe that Sam came to the Cape simply to procure a ship also believe that the couple shared the equivalent of a one-night stand and that Sam knew nothing of Maria's pregnancy when he left Cape Cod.

Still, Maria liked Sam's bold and daring nature. She believed in his dreams and she made them her own. Sam was not like the boys she knew in town—boys destined to farm and labor until death. No, Sam was a man who knew what he wanted and went after it with an unparalleled zeal. Such a beautiful girl like Maria could have married any man from Falmouth to Wellfleet. But they were all the same. She, like Sam, knew what she wanted and went after it. The couple looked forward to a wealthy future and a true partnership. The goodbye must have been more than difficult, but they knew it was necessary.

Not long after, Williams and Bellamy set sail with a small crew of men. Williams served as quartermaster, and once they reached Florida, he would make sure that the treasure was divided equally. Together these men set their sights on the glittering waters off Florida. Sam, full of expectations and confidence, strode the deck in anticipation, while Maria went home to wait for his return.

CHAPTER 3

Secret in the Barn

In a couple of month's time, Maria realized that she was pregnant with Bellamy's child. As discussed in the previous chapter, there are those who believe that Maria's pregnancy was known to Sam before his departure. And while Sam was surely a dreamer and treasure seeker, he certainly would have had to speed up his plans to secure funds if he were to provide for Maria and their baby. By all accounts, he loved the girl and would not have deserted her and their unborn child. In fact, he promised her that he would return in six month's time—perhaps in time to welcome his new son or daughter into the world.

Most of the stories maintain, however, that Maria learned of her condition about two months after Sam set sail. Bellamy, focused on glittering coins and Spanish galleons, had no idea of the shame and torture Maria would endure because of their afternoon in the apple orchard.

While fifteen-year-old Maria's situation was certainly worrisome, it was not uncommon. Birth control, though available, was not widely used in colonial America, and many young couples "coupled" before they said "I do." In fact, some records suggest that upward of 25 percent of children were conceived out of wedlock. While the Puritan elders certainly preached against these unsanctified unions, the issue was not only a religious one in the colonies.

Prior to 1700, Maryland had enacted laws concerning the pregnancies of unmarried servants. The early colonists depended on these indentured servants, and pregnant women could not perform their duties fully until a year after the birth of their children; pregnant women were subject to illness and even death, while new mothers had to breastfeed their children. In addition to losing money, their masters often incurred the added cost of caring for the children. Such cases usually ended up in court, and the women (after receiving lashes) were ordered extra days to serve. Many studies have been done as to the fairness of this practice, but the bottom line is that promiscuity certainly caused problems within the structure of colonial society. In Massachusetts, too, the problem persisted. Who would care for these bastard children? A Massachusetts Act of 1692 stated that "despite his denial, a man who was accused by a woman under oath at the time of her travail would be adjudged the father of the child and be responsible for its support with the mother, thus relieving the town of the child's care."

While Maria came from well-to-do farmers and was not an indentured servant, her love for Sam put her in a difficult situation. Had Sam remained on Cape, he and Maria would have surely sought Reverend Treat once they realized that Maria was with child. Before her stomach began to swell, Maria would have wed her true love, and no one would have been the wiser. Many couples, overzealous in their courtships, were forced to make haste to the local altar before their untimely trysts were discovered. But Sam was many months' sail away from Eastham, and Maria did not have that option.

Maria could have married a local boy to make her situation "okay." She was undoubtedly still the most beautiful girl in the region, and her dowry would have been handsome as well. No one need know that the child belonged to another man, and the arrangement would suit both husband and wife. In fact, many girls in Maria's situation chose to do exactly that. But Maria, who sought the dunes daily in anticipation of Bellamy's return, could not imagine giving her hand or her body to another. Sam had made her a promise—a promise to return with a ship full of treasure and marry her—and she clung to that promise. How could she marry another man?

Maria was, however, well aware of the punishment that awaited her from the Puritans of Eastham. She would certainly be made to pay a fine, and she would probably be publicly lashed. The Massachusetts Act of 1692 included whipping and fines for those found guilty of fornication. In a town where she had always been lauded for her beauty, she would be shamed and judged. The people would view her as obstinate because she refused to divulge the father or marry him. She refused to marry anyone for that matter. The locals simply could not comprehend the workings of Maria's heart. They began to view her as stubborn, loose and even wicked.

Young women like Maria were indeed ostracized and made examples of in their communities. A famous speech given in 1747, and now reputed to have been written by none other than Benjamin Franklin, illustrates the plight of unwed mothers during the eighteenth century. In the voice of Polly Baker, an unwed mother of five, Franklin, through his satire, gives voice to some of the frustrations that Maria most certainly must have felt (an asterisk indicates an illegible section):

This is the Fifth Time, Gentlemen, that I have been dragg'd before your Courts on the same Account; twice I have paid heavy Fines, and twice have been brought to public Punishment, for want of Money to pay those Fines…I take the Liberty to say, that I think this Law, by which I am punished, is both unreasonable in itself, and particularly severe with regard to me, who have always lived an inoffensive Life in the Neighbourhood where I was born, and defy my Enemies (if I have any) to say I ever wrong'd Man, Woman, or Child. Abstracted from the Law, I cannot conceive (may it please your Honours) what the Nature of my Offence is. I have brought Five fine Children into the World, at the Risque of my Life: I have maintained them well by my own Industry, without burthening the Township, and could have done it better, if it had not been for the heavy Charges and Fines I have paid…I have debauch'd no other Woman's Husband, nor enticed any innocent Youth: These Things I never was charged with; nor has any one the least cause of Complaint against me…I appeal to your Honours. You are pleased to allow I don't want Sense; but I must be stupid to the last Degree, not to prefer the honourable State of Wedlock, to the Condition I have

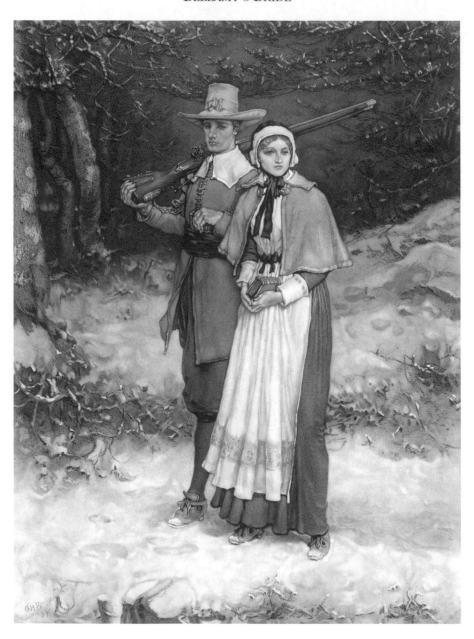

Puritans Going to Church. Library of Congress.

lived in. I always was, and still am, willing to enter into it…I readily Consented to the only Proposal of Marriage that ever was made me, which was when I was a Virgin; but too easily confiding in the Person's Sincerity that made it, I unhappily lost my own Honour, by trusting to his; for he got me with Child, and then forsook me…If mine, then, is a religious Offence, leave it, Gentlemen, to religious Punishments. You have already excluded me from all the Comforts of your Church Communion: Is not that sufficient? You believe I have offended Heaven, and must suffer eternal Fire: Will not that be sufficient? What need is there, then, of your additional Fines and Whippings?…if you, great Men…[]…must be making Laws, do not turn natural and useful Actions into Crimes, by your Prohibitions. Reflect a little on the horrid Consequences of this Law in particular: What Numbers of procur'd Abortions! and how many distress'd Mothers have been driven, by the Terror of Punishment and public Shame, to imbrue, contrary to Nature, their own trembling Hands in the Blood of their helpless Offspring! Nature would have induc'd them to nurse it up with a Parent's Fondness. 'Tis the Law therefore, 'tis the Law itself that is guilty of all these Barbarities and Murders. Repeal it then, Gentlemen; let it be expung'd for ever from your Books.*

Maria, who did not have the experience or confidence of Polly Baker, turned to her parents. They ordered her to divulge the name of the father, but she refused. Some say they banished Maria. Others say the townspeople banished her to the area that is now Marconi Beach. Still others believe she was able to hide the pregnancy from her family and the townspeople alike. Whether Maria kept her pregnancy a secret, confided in her parents or exposed her burden to all of Eastham doesn't really matter. The result was the same. Maria sought the security of the dunes, where she built a hut and continued her pregnancy in peace. And that is when the talk began—they said that Maria was a witch.

When the baby would stay hidden no longer, Maria made her way to her parent's home or her uncle's barn, depending on the tale. They say that Mr. Hallett woke one night to inhuman cries of pain and terror. He followed the screams to find his daughter, Maria, cradling a lifeless babe in her arms. Mr. Hallett quickly exited to find a doctor and a priest. When

he returned, Maria's anguish had given way to calm. Hallett watched as his once innocent and beautiful child transformed before his very eyes. She invoked Satan himself and cursed Bellamy—he would pay for the death of her child.

Most storytellers agree that Maria delivered the child herself, which would have been a common practice for an unwed mother who was attempting to hide her pregnancy. And while in one rendition, she gives birth to a girl, she produces a son in every other story. They say the boy resembled his father—if Bellamy was indeed his father—the striking Englishman with black hair and eyes. Some say the child died on the very night it was born. Others believe that the child lived for a brief time, perhaps days.

Maria was afraid to show the child and hid him in John Knowles's barn. The man may have been her uncle, or perhaps his barn was simply a convenient place for Maria to hide her child. Regardless, Maria concealed the infant and returned often to feed him in most versions. One day, while Maria was gone, the child choked on a piece of straw and died. Knowles found the lifeless boy in his barn before Maria returned, so he hid in the barn to confront his niece. Others say that the infant froze to death and that Knowles discovered Maria on his land as she bent over the earth to bury her child.

The name of the father and the scandal of her pregnancy no longer mattered. Poor Maria was now suspected of murdering her love child. Indeed, as pointed out in the Polly Baker letter, desperate women sometimes murdered their babes for fear of exposure and punishment, or at least they were accused of doing so. Compounding the issue was the fact that it was difficult for authorities to tell the difference between a natural death and suffocation. Women who hid their pregnancies and subsequently lost their children were accused of murdering the evidence.

About twenty years after Maria's ordeal, in 1733, a twenty-seven-year-old unmarried woman named Rebekah Chamblit was hanged in Boston for the murder of her child under circumstances that closely parallel Maria's case. While her declaration was probably doctored to justify her execution, she uttered these words prior to her death:

On Saturday The Fifth day of May last, being then something more than Eight Months gone with Child, as I was about my Household Business reaching some Sand from out of a large Cask, I received considerable Hurt, which put me into great Pain, and so I continued till the Tuesday following; in all which time I am not sensible I felt any Life or Motion in the Child within me; when on the Said Tuesday the Eighth of may, I was Deliver'd when alone of a Male infant; in whom I did not perceive Life; but still uncertain of Life in it, I threw it into the Vault about two or three Minutes after it was born; uncertain I was, whether it was a living or dead child.

Maria, like Rebekah Chamblit and many other women of the day, was really guilty of one crime—premarital relations that resulted in pregnancy. The Bastard Neonaticide Act (a favorite of Cotton Mather's) provided a frightening scenario for young unwed mothers whose infants did not survive. Unless the woman could provide a witness to the birth, then the dead child served as evidence of her guilt. Despite the nature of the child's death, under the law a woman had no recourse. Whether the child was stillborn or its death accidental, the mother was charged with, and some were even convicted of, murder. Of course, as many women were trying to hide their pregnancies, they did not invite witnesses to the childbirth; therefore, these women found themselves subject to the noose despite their guilt or innocence.

Maria, still mourning for her dead child and recovering from childbirth, was accused of her son's murder and taken to the Eastham jail. She had known heartache and loneliness when Bellamy boarded his ship for Florida; she had known heartache and loneliness when she was ostracized from the family and the town that had reared her; and she had known heartache and loneliness when she gave birth to her son in her uncle's barn. But Maria was no longer a child. She was a mother, robbed of the life that had moved within her for the past nine months, a mother accused of destroying that which had been so much a part of her. Now sixteen years of age, she was facing death. The carefree and wild beauty of Eastham was officially gone.

CHAPTER 4

The Devil Comes
to Eastham

If Maria had been considered strange when she first built her hut on the dunes, her stint in the Old Eastham jail cemented her reputation as a devil-dealing witch. In fact, during the time that Maria hid her pregnancy, she had already exhibited many signs that would have earned her the superstitious title. In seventeenth-century New England, any person who chose to separate himself or herself from the community was suspect. Most of these people, reclusive and eccentric, eschewed their neighbors and rarely took the time to defend themselves against their accusers. Sometimes these men and women suffered from mental illness, and sometimes, like Maria, they had specific reasons for leaving their communities. In addition, these people rarely attended religious services and were certainly, therefore, the devil's followers.

As early as 1651, the Eastham settlers had imposed laws concerning religious services. According to Enoch Pratt's history of Eastham, "It was ordered by the Court, that if any lazy, slothful or profane persons, in any of the towns, neglect to come to the public worship of God, they shall forfeit for every such default, ten shillings, or be publicly whipped." He states that again, in 1665, "The Court passed a law to inflict corporal punishment on all persons who resided in the towns of this government, who denied the scriptures" and "all persons who should stand out of the meeting-house, during the time of divine service, should be set in the

stocks." In concealing her pregnancy, Maria separated herself from her community and her religion. Rumors circulated, and Maria must have been aware of such rumors, but she had only two concerns at the time: the return of her lover and the birth of her child.

As Maria was escorted from Knowles's barn, she would have been accused of several crimes resulting from her relationship with Bellamy, the worst of which was the murder of her bastard child. The town elders removed her from the barn and brought her to the village— where a brand-new whipping post had just been installed, compliments of Deacon Doane—in order to make an example of the poor girl. Maria would have been shackled or tied to the post with her back to the whip. These whipping posts were usually placed next to the stocks, and the townspeople gathered to view the shameful punishments. Having just endured the birth and the death of her child, Maria was weak, exhausted and defeated; still, she was forced to undergo the sting of both the lash and public shame. She begged Harding Knowles and the others to let her die. They would not grant her wish so soon, nor would they allow her to take her own life. Eleanor Early describes the scene of Maria's torment in her 1936 book *And This Is Cape Cod*:

> *The poor girl asked only that she be allowed to die, and while the town fathers were inclined to oblige her in this, a little writhing first, they thought, might serve as a valuable warning to others of the godless younger generation of their day. The gaoler was cautioned against bringing Goody any victuals that wanted cutting with a knife.*

In a strange twist, tragedy can often create beauty, and such was Maria's desperate condition. Once Maria was brought to the Eastham jail, her grief only enhanced her beauty. Elizabeth Reynard describes her as "Wild as the Nauset Wind" with "wistful eyes and silky hair" as she pleaded with her jailor to set her free. Her deep blue eyes were wet with tears, and her blond strands fell softly around her face. She was vulnerable and, therefore, persuasive. Only a hardened jailor or a stoic man could resist Maria's charm. The first time she escaped, she went straight to the dunes and desperately searched the horizon for the one man who could share her grief and soften her torment. Soon, however,

the selectmen sent after her and restored the poor girl to the Eastham jail. At least three times Maria fought her way beyond the prison bars, and at least three times the sheriff pursued her. In truth, she wasn't very difficult to find. She could be found either on the backside of the Cape seeking Bellamy's sails or in the apple orchard seeking solace.

The jailor, though sympathetic to Maria's plight and charmed by her beauty, was no fool and admitted no responsibility for Maria's escapes. Talk in the town, therefore, turned toward supernatural explanations. Either Maria bewitched her captor or she entertained the devil.

As the legends tell, one day a stranger entered the stone jail and peered in at Maria, who by this time was nothing more than a small and fragile shadow on the cold floor. Dejected as she was, she begged the man to take pity on her. She could tell by his dress that he was no jailor or local. In fact, he was "dressed in fine French bombasset, and he carried a gold-tipped cane." Maria was seemingly entranced by the stranger's presence. The devil himself had come to the girl's aid, and with a tip of his cane, he eased Maria's wild heart. She had been wronged by her neighbors, he assured her, and he would come to her rescue and lighten her burden. Elizabeth Reynard recounts their fancied meeting in her book *The Narrow Land*:

> One of the iron cell bars stood between their faces. He reached out, took it lightly between his thumb and finger, and flicked it away—clean out of the window-frame—as if it were no more than a stray bit of ryestraw. Then he smiled and slowly shook his head.
>
> "Ah, these stiff-necked hym-bellerin' Yankees! I tell ye, sometimes they make me feel like the rawest greeny ever went on the account!"
>
> The words meant nothing to little Goody Hallett, but in the man's voice there was something smooth and westerly, something that tautened the spell.
>
> "Now, my girl," he went on, flicking another bar out of the window, "I'm going to play ye fair and square, cross my—er, by yer leave. Ye're young, but ye've showed old enough, sartin, for the employment I can get ye. Ye can forget all this, child," and with a gesture, he tossed away still another bar from the window. "Yer life's still before ye. 'Tis all in the future—yes, hmm!"

Soothingly, softly, he went on talking to her, but once he had led up to it properly, he made no bones about who he was. And as he spoke, from time to time he punctuated his remarks by taking out the bars from the window, until all were gone, and Goody Hallett's way to freedom lay clear. Also, the while he spoke, the girl felt bitter against those who had not let her die; and beguiled into vengeful thoughts, she listened and nodded. At last he took a paper from his waistcoat.

"Can ye write, Goody? Well, no matter. A mark's as good. Just put it there, where the line's broken into small grains."

He touched a gold quill to his tongue, and as Goody took the quill, she observed that the tip glistened scarlet. She was about to make the mark when he caught her arm.

"What! Tricks, is it? So soon?"

His eyes were suddenly like fiery drills, and his fingers bruised her. But after a moment, he smiled again.

"Young, aye! I forgot ye're but a child, Goody Hallett. Go and make yer mark; but if it's to be two lines, ye'll oblige me to make 'em slantindicular, like an X—not any other way."

Goody understood. And that night she disappeared from Eastham Gaol and before her case could come up in General Court, the town of Eastham found that lock and bars could not hold Goody Hallett.

The latter story reminds us, first of all, that Maria was just a child—a fact that even the devil forgets. She had been forsaken and humiliated by her family and her town. Had they punished her solely for her tryst with Bellamy, she might have been able to endure the lash and pay the fine. But they took a young mother, who had delivered her own child and suffered its death in a matter of days, and accused her of the child's murder. Bellamy was gone, her child was dead and she stood accused of fornication and infanticide. The people also suspected her of witchcraft. The devil, then, represented her only hope. How could the desperate girl refuse?

It seems the devil was very busy collecting New England souls; he was so busy that Cotton Mather, the infamous Puritan minister, weighed in on the issue in his essay "The Devil in New England," found in *The Wonders of the Invisible World* (1692). Mather begins with the typical Puritan

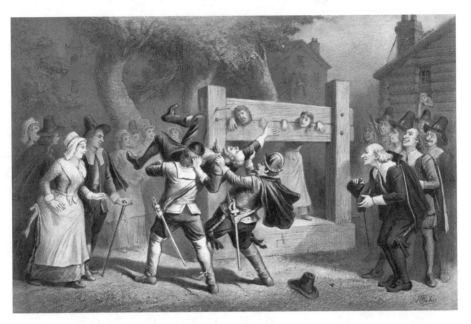

The Witch, No. 2. Library of Congress.

view that "the *New-Englanders* are a people of God settled in those, which were once the *Devil's* territories; and it may easily be supposed that the Devil was exceedingly disturbed, when he perceived such a People here accomplishing the Promise of old made unto our Blessed Jesus, *That he should have the Utmost parts of the Earth for His Possession.*" The devil, Mather purports, was building an army of witches to take over New England. The minister rallied the people to battle against the devil and all of his followers—even those in the guise of their innocent neighbors. It's telling that such an educated man not only subscribed to but also fueled the early witchcraft hysteria.

While Mather painted the devil as a foul creature, the devil rarely presented in a frightening manner—he was often well dressed and well spoken. Washington Irving and Nathaniel Hawthorne would later paint images of the devil much like the image of the man who visited Maria in her Eastham cell—calm and sophisticated but subject to flashes of violent fury.

Regardless of Mather's scare tactics, reasonable men existed in the early eighteenth century, and many of them lived on Cape Cod. Devils

Marconi View. *Photo by the author.*

and witches made for delicious fireside lore, but gossiping of witches was altogether different from hanging witches—a practice shunned on the Cape. Eleanor Early tells of Goody Holmes, another Cape woman accused of witchcraft by her neighbors. According to her neighbors, Goody Holmes was having an affair with the devil. Rather than legitimize the ladies' gossip, the Cape magistrates had Holmes's accusers publically whipped and fined!

In the end, Maria never went to trial for murder or witchcraft— or anything at all. Some say she was stoned out of town. Eventually, however, the elders grew weary of chasing and jailing the pathetic girl, and they released her to the small hut she had built by the sea. There, on the backside, in what is now South Wellfleet, Maria made her home by the cliffs. The local women brewed fantastic tales of Maria Hallett, and even the men shuddered as they passed her hut. For her part, though, Maria was weary. She could not undo the events of the previous nine months, she could only look to the sea and await Bellamy's return. Little did she know that all of her previous suffering was only a prologue to further tragedy.

CHAPTER 5

Ocean Views

According to the stories that have been passed down, Maria was doomed to spend many lonely and arduous months waiting for Bellamy's return. They say that she occupied much of her time by the sea on what is the present-day Marconi site. Down by the ocean, day after day, Maria focused on the sky of orange and yellow swirls punctuated by intermediate clouds. In the distance were brown specks and peaks that she believed to be land. As a child, she imagined that the land was England, the home of her grandparents. Her papa used to take her in his suntanned arms and gesture toward the horizon. But the great cathedrals and playhouses were difficult for Maria to picture—for she lived in the new land, with its small cottages and the common building. If only England were beyond the top of those waves, she would surely seek another life there. Someday, she promised herself, she would brave the distance and walk London's crowded streets—she would return to her source.

She remained there by the ocean on many days, her legs at her chest, and daydreamed before she resigned herself to each cold evening ahead. As she turned to rise, Maria often noted another figure contemplating the ocean. From the distance, he always appeared like a green and grayish swirl. The orange of the sky picked up the orange of the sand and blended into one canvas. Only he stood out.

The view that Maria Hallett would have experienced as she waited for Bellamy's return. *Photo by the author.*

She could tell that he was the same man who had taken her maidenhead in the apple orchard so long ago. Not wanting to startle him, for he never took any notice of her, she sought his view of the sea. He had lived in that distant home of kings and queens and guards, and he had promised to take her there.

There can be no doubt that Maria often fantasized about Bellamy's return. At the thought of Sam, Maria could feel the folds in her skirt, hear the quick and labored sound of her own breath and feel the heaviness of her legs each day as she spied the same strange silhouette in the sand. She was sure that he noticed her fumbling manner, and though not usually embarrassed, she always shuffled and twisted, less someone catch her strange behavior on the sand. She could not help but remember the different sound of his voice; his words were slightly more pronounced and rose in strange places.

She often moved her eyes from the ocean to the sand again, but the image was gone. How many days did she imagine his figure in the dunes? How long would it be before he returned and they joined hands in front

of Reverend Treat in the new meetinghouse that the townspeople were building over in Yarmouth? How many mirages did she have to endure before she could raise her head in front of her pious neighbors—the men and women who singled her out and made her an example despite their own nocturnal adventures? And what had she done but remain true to the man she loved?

Maria's eyes filled on many days, and she often shifted her gaze upward to avoid the tears. Hardened by the events of the previous year, she would not allow such moments of weakness. Instead, she focused on the sea, its rhythmic ebb and flow. The ocean was her only ally and she believed in it.

Bellamy looked at a different ocean. His stride was purposeful and confident; from the deck of his ship, Sam concentrated on the turquoise waters of the Caribbean. The gold and silver coins that littered the Florida coast were gone by the time he and Paulsgrave arrived. The Spanish recouped what treasure could be found, though most of it lay on the ocean floor undisturbed for centuries. Undeterred, Bellamy refused to go home empty-handed. Sam believed that destiny had singled him out. Though destitute, he could feel the palpable hand of fate on his shoulder. Surrounded by young treasure seekers, he knew the pull of the Jolly Roger and the certainty it represented. For the first time in his life, he would steer his own destiny as a free man.

Bellamy and Williams proved no different than the other English sailors who found themselves in the South Seas in the fall of 1715. After the war of Spanish Succession, a slew of trained privateers flooded the Caribbean. Both pirates and treasure seekers, these Englishmen were not ready to stop their plunder of foreign vessels.

Sam and Paulsgrave sought out Benjamin Hornigold, the famed father of pirates. Hornigold, an apt name for a pirate, was one such sailor who had served in Queen Anne's War. He and fellow Englishman John Cockram founded a pirate haven on the island of New Providence while Bellamy was still busy wooing Maria Hallett on the shores of Cape Cod. Hornigold served as a mentor to many of the men who would later become far more famous, or infamous, than he. One of his most loyal students was Edward "Blackbeard" Teach, with whom Bellamy may have served while under Hornigold's command.

Pirates Approaching Ship. Howard Pyle.

There was no shame in plundering the seas, Hornigold told his men. For centuries, false governments took land and treasure for themselves while it was the people who secured them. No. Hornigold's pirates were crusaders, for they were unwilling to subject themselves to the bogus rules of sovereign nations. White men, black men and red men, they created their own nations, and they sought treasure in fair battles over the open ocean. If another crew could not hold on to its ship, it did not deserve the ship.

By the time Bellamy joined Hornigold's crew, he had already committed his pocket and soul to piracy. Bellamy was believed to have turned pirate sometime between the fall of 1715 and January 1716. Not only had he successfully seized a French merchant ship with notable pirate Henry Jennings, but he had also managed to lift a large portion of that booty for himself. Once Bellamy and Williams had safely, and wisely, joined Hornigold's crew, they were protected from Jennings's outrage.

By the summer of 1716, Bellamy and Williams immersed themselves in the pirate's art. And in those same Caribbean waters, Bellamy rose far beyond the sailor status he had once known in England. Unlike his pirate mentor and captain Hornigold, Bellamy had no reservations about attacking the merchant ships of his native land. The crew was also frustrated with Hornigold's loyalty to the Crown, and they were as eager as Bellamy to seize the king's vessels. The dichotomy proved to Bellamy's advantage, and he knew it. The men put the matter to a vote, for the majority opinion was always respected under the democratic pirate code. The crew voted unanimously to oust Hornigold as their captain and to replace him with Bellamy.

By the fall of 1716, Bellamy was well on his way to securing the fortune he had promised Maria. He and Williams had cut free from Hornigold, and they were truly masters of their own destiny. By nature, however, Bellamy was never satisfied. Though in the span of a mere year he had taken over fifty vessels, Bellamy longed to find a magnificent galley to lead his flotilla. He longed to sail a string of fine ships to the Cape and claim his princess. Maria's parents would gladly accept him then.

Handsome Pirate. Howard Pyle.

He decided to bide his time and build his treasure fleet, while Maria waited in her makeshift hut on the bluff. One can assume that Bellamy, finally a free prince, enjoyed his swashbuckling days of high seas adventure. Maria, however, lived a desperate and isolated life on the dunes. Her future depended solely on Sam's return to Cape Cod. No doubt they each eyed the same sea—he from his wooden deck and she from her barren bluff. And as its cadence rolled in their nightly thoughts, they dreamed of their future together.

The Sea Witch of Billingsgate

The tradition goes that a sea witch haunted both the shoals and shores of the Cape about the same time that Maria waited for Bellamy's return. Sailors huddled below deck in prayer as the glow of her tell-tale red heels flashed in the waves on moonlit nights. She was bartering for their souls, and the men searched in fear for her familiars—a cat and a gray goat with one glass eye. They knew of her nightly dealings and adventures, for she had taken more than one of their kind out on her evil errands. Yes, they knew her well. She screeched her satanic laughter over the seas, and multiple shipwrecks lay in her wake.

According to Elizabeth Reynard and folk tale collectors of the early twentieth century, poor Captain Sylvanus Rich was one of the sea witch's many victims. He never should have docked his ship on the backside of the Cape, for stormy weather would have been preferable to the frightening adventure he endured at the red heels of the sea witch.

It all started one day when the elderly captain was set to deliver corn to Boston. Not liking the ominous face of the sky, he stopped off in Truro and went ashore to buy provisions. A haggard and sickly looking old woman sold him a bucket of milk. The captain took notice of the scarlet-heeled shoes below her gray skirt, but the old man should have paid more attention to her signature soles than he did.

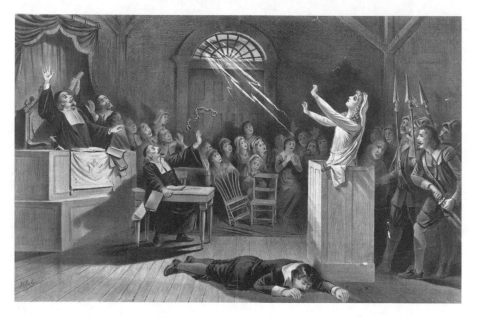

The Witch, No. 1. Library of Congress.

As planned, the captain waited for more suitable weather before he set sail to Boston. But once he began to wrestle the waves, the fickle winds stirred up again. His ship sustained great damage, but the damage was only the beginning of the captain's troubles. Reynard tells of his woes:

> *The milk, he maintained was bewitched. For every night at moonrise an old woman with scarlet heels on her slippers came in to his cabin. She put a bit in the captain's teeth. She saddled him and bridled him, and all night long she rode him over the Truro hills. Along the coombs and through the wood, up the dunes and down the dunes, across the inlets, through the town, even around Bound Brook island! Captain Sylvanus had to carry the witch wherever her fancy drove.*

After these nightly visitations and subsequent adventures, the elderly captain was in no condition to pilot his ship. He grew dumb and pale. He even locked himself up in his cabin. Luckily, his son, who was old enough to captain a ship of his own, came up beside his father and helped the old man and his crew to safety.

Some years after the legend of the sea witch began, Maria Hallett was stoned out of Eastham, and the young girl set out for the dunes of what is now Wellfleet. Maria chose to live far from the tattling townspeople who cast her out; so with her very own hands she built her rudimentary hut on the backside.

The land was not fertile and has been described as sand stubble—a mixture of poverty grass and sand. For this reason, the area was dubbed "Lucifer Land" or "Satan's Harvest." These titles illustrate the loneliness of the spot, but Maria must have preferred it that way. She'd had enough of Eastham jails and whipping posts. Besides, from the height of the dunes, she could look out to the sea and the waves on which Bellamy promised to return. She placed every hope she had on the young man and the future they had planned. Some say that talk of Bellamy's piracy had reached Cape Cod and that Maria knew that her lover had gone on the account. Perhaps she did not care. Perhaps she felt betrayed. Regardless, she had no choice but to wait for his return.

Land near Maria Hallett's meadow. *Photo by the author.*

Though the area on which Maria settled was barren, she necdn't travel far for provisions. In Charles F. Swift's *History of Old Yarmouth*, he tells of the fruitful conditions enjoyed by the early settlers of the Cape:

> *The old fields at once yielded a crop of corn and vegetables. The coves and ponds swarmed with fowl and fish, the shores were stocked with shellfish, and the forests abounded with game.*

In addition to hunting and fishing, Maria sustained herself through weaving. She was said to weave the most beautiful cloth—no homespun was as elegant or durable. Reynard describes her talent as a spinner:

> *No woman on the peninsula wove the beautiful patterns that Maria Hallett knew how to draw from her loom. Many fine weavers tried to copy them, but the wools snarled and the designs faltered, so Maria took in weaving in exchange for bread.*

Her weaving was so well regarded by those who had condemned her as a witch and a whore that they traded with her or paid her for her products. Still, though, they shuddered and whispered as they walked across the sand meadow, for they all knew that they must say a prayer as they stepped on that forsaken land or bad luck would befall them.

The image of Maria Hallett—standing on the majestic cliffs of Wellfleet, her hair billowing in the evening winds as the ocean crashed and sprayed below—must have been an eerie sight for those who visited her hut. The children began to tell tales of the "strange capers" she cut each evening on her "nocturnal stomping grounds."

So began a transformation born the day her infant died in Knowles's barn. The once beautiful and charming belle of Eastham had become the strange and haunting woman of Nauset. Soon the people started to confuse Maria with the sea witch of Billingsgate. According to Jeremiah Digges, who published the *Cape Cod Pilot* in 1937, some of the townspeople believed that the sea witch stole poor Maria's soul: "Among the poor souls that were 'betaken' was pretty little Goody Hallett of Eastham. Goody was only fifteen, and no more knowful of the black arts than a babe in swaddlecloth."

Yet Maria and the red-heeled witch became synonymous in the stories told by the hearth on raw Cape evenings. The Truro witch, known for her beauty, morphed with Maria—and Goody Hallett emerged. This same sea witch was blamed for so much misfortune on sea and land that people claimed she had as many lives as familiars. Who came first, they wondered, the sea witch of Billingsgate or Maria Hallett? Or were these witches always one and the same?

Regardless, well after Bellamy's prize ship, the *Whydah*, rested beneath the waves off Wellfleet and Maria rested beneath the earth, the sea witch or Goody Hallett continued to haunt the area and its inhabitants. As late as 1780, she was still said to be active. Evidence lies in an old tale of the sailor and the doughnuts recounted by Reynard and many others.

It appears that old sailors were not the only victims of the sea witch, for she haunted young and old, rich and poor alike. As late as 1780, an innocent, young and hungry sailor was on shore leave. As he traveled along the old King's Highway in Nauset toward his ship in Provincetown, he found a hut. An inviting aroma of freshly baked doughnuts filled his nostrils, and he followed the smell to the small house. The door, which was unlocked, gave way with his touch. Inside, the sailor found a black goat lying by the hearth and a stack of doughnuts on a wooden table nearby.

The goat, a familiar of the sea witch and also a familiar of Goody Hallett, spoke nonchalantly to the young man as she greeted him from the rug on which she lay. Focused on the fire, she did not seem alarmed or even disturbed when the young sailor helped himself to a few of the doughnuts. The young lad planned to leave payment, but as he was only a poor sailor, his pockets were as empty as his stomach.

Once the sailor left port under the direction of Captain Ridley, his sickness manifested. The captain visited him frequently to ascertain the extent of the sailor's illness, for he did not want a sickly crew, especially not at the beginning of the trip. The crew soon came to believe that the poor sailor was bewitched, for he always appeared unconscious or sleeping though they could not rouse him. After many dousings, the sailor would return to his unconscious state. Even when he remained awake long enough to fetch water for the other crew members, the water he drew was full of salt and deemed undrinkable.

The sailor confided in Captain Ridley. He told him about the doughnuts and the witch to whom they belonged. He said that she visited him every night to punish him for stealing from her. The moment he fell asleep, she entered his chamber, bridled him and rode him over Sable Island. Indeed, the sailor was bruised and battered throughout his body.

Now, Captain Ridley was a wise man who put the needs of his crew before his own. One ranting sailor could destroy the morale of an entire crew. Besides, though Ridley had doubted the sailor at first, he now believed the poor man's tale.

So Captain Ridley gave heavy consideration to this problem. He knew a bit about witches from the old tales told around his boyhood hearth. He grabbed his meeting coat and gazed at the silver cufflinks affixed to each sleeve—the same showy cufflinks his wife had scolded him for wearing. The captain knew that silver had the power to destroy witches, and he believed that he could save the young sailor. Opening his pistol, he deposited the silver cufflinks in the chamber and walked to the afflicted man's cabin. Instructing the sailor to shoot for the hag's heart, he left the room and waited.

After Ridley heard the shot, the first mate informed the captain that the young sailor lay covered in blood but otherwise unharmed. The sailor was alone, and his mates could not figure out what had happened to him. But Captain Ridley knew that the silver bullet had worked and that the sea witch would no longer bother his crew.

Though Captain Ridley never dealt with her again, she was known to accost her share of sailors over the centuries. For many years, the men of the Cape yielded to the sea. The saying goes that as soon as they were ready to walk, they were ready to sail. But as the days wore on and whaling ended, men no longer sought their glory on the oceans off Cape Cod.

With the advent of tourism, some say that the sea witch of Billingsgate has all but disappeared. Although others believe that she has simply moved on to another port, there are still those who assert that when you hear the gull's cry in the echo of the wind, a scarlet pair of shoes is soon to follow. Beware the faint ruby glimmer in the moonlit sky, for the sea witch is surely embarking on an evening of mischief.

Wreck of the Whydah

Though a great winter snow had laced the tip of the Cape in February 1717, April whispered the promise of spring with its warm winds. The sweet smell of the air seemed to indeed signal the long-awaited change of season.

Maria's hope, like the budding tendrils below her feet, resurfaced with the warmer weather. For the spring brought an influx of ships to the Cape, and each day held the promise of Bellamy's return. She continued her vigil in the dunes, searching for his white sails.

She was a wiser girl than she had been when he departed, for the events of the previous two years had forced her hand. She delivered life and suffered death. She lost home, family and reputation. On the one stretch of sand she could call her own, she carved out a meager existence. But as the days wore on, she grew strong and independent. And one day, she knew that Bellamy's return would lift her sentence. Together, they would travel far from the scene of her torment.

Some storytellers paint a darker picture of those spring days prior to Bellamy's return, in which Maria grew bitter and weary of the pirate's promise. She feared his betrayal and prayed to the devil that Sam suffer for the death of their child and her subsequent shame. With the fiend's aid, Maria conjured the greatest nor'easter in the Cape's history—so great that it split the land and created the first canal until the people

closed it up. She gave her very soul in exchange for the pirate's death, and the devil brought the pirate's body right to her doorstep; he was far better at keeping his word than Black Bellamy had been. So in the middle of what had promised to be a mild month, the ocean rose its angry fingers and betrayed Bellamy, the scourge of the seas.

They say, though, that Bellamy never forgot his pact with Maria. He remained true to the girl with the kettle-pond eyes and worked daily to make enough money to return to her a wealthy man. The pirate life was not a stable life, but it was an honorable life—at least among pirates. Bellamy, never satisfied with the many ships he had plundered and captured over the previous year, waited for a prize ship so large and so grand that he could capture Maria's heart all over again. Then he would be a true prince and worthy of his Cape Cod girl.

When the impressive sails of the *Whydah* crossed Bellamy's path in February 1717, he knew that he had found his prize. He and his crew gave chase for three long days before the magnificent galley surrendered its holds of gold dust, silver bars, doubloons and pieces of eight. Its cargo held the necessary riches for Bellamy to return home and marry Maria. Bellamy was in a grand mood. Never one to inflict unnecessary injustice, Bellamy gave the *Whydah*'s captain the *Sultana*, his own ship, and sent the man away unharmed.

After much celebration, the pirates headed north, for spring promised the sail of merchant vessels along the coast and the opportunity to add treasure and ships to their fleet. Eventually, Bellamy and Williams planned to meet up on Green Island in Maine, where the thick forest could serve as the perfect colony for his fellow pirates and their treasure. First, however, Bellamy had a promise to keep.

Along the way to Cape Cod, Bellamy's crew raided more ships. They sank some and added others, among them the *Mary Anne*, a merchant ship from Dublin captained by Andrew Crumpstey. It was a snow heavy with sweet Portuguese wine, and Bellamy sent some of his crew aboard the ship. They partook of its cargo almost immediately, starting with the captain's private stock, while the captain remained with Bellamy on the *Whydah*.

As Bellamy approached the Cape with his fleet, the winds picked up and the rains poured down. They reached the outer shoals at about ten

o'clock in the evening. The *Whydah* had already weathered one major storm on its way north, so Bellamy was feeling confident. His crew was so jovial, in fact, that they scripted and performed a play on board. Typical of pirates, however, their thespian adventure turned violent, and Bellamy forbade the performance of the play again on his decks.

As the storm increased, the *Whydah* came across a sloop, the *Fisher*, and Bellamy questioned its captain, Robert Ingols, about his experience in Cape waters. Bellamy hoped the man could guide the *Whydah* safely to Provincetown.

In the confusion of the storm, many of the ships were separated. Legends state that the captain of the *Mary Anne* took advantage of Bellamy's drunken sailors and regained control of his ship. In truth, however, the captain never saw his ship again. A handful of Bellamy's pirates took over the *Mary Anne*; hardy and trained sailors, these pirates weathered the night successfully and woke with their lives. As Barry Clifford points out in his book *Expedition Whydah*, pirate Thomas Baker had enough sense to chop down the "foremast and mizzenmast to keep the ship from tipping over when she hit the shore."

Legends would also have us believe that the captain of the sloop led the *Whydah* to its destruction. They assert that Ingols distrusted Bellamy and feared that the pirate and his crew might do harm to the people of Provincetown; therefore, he hung out a lantern and piloted his ship toward the bars so that the mighty *Whydah* would follow. His sloop was much smaller than Bellamy's grand galley and would not be destroyed, but the heavy *Whydah* would run aground for sure. Others, like Henry David Thoreau, say that the captain threw a burning tar barrel overboard, which the *Whydah* followed as it floated to shore. As far as we know, Bellamy ordered each ship to hang a lantern. The darkness was compounded by the rising surf and gale-force winds; Bellamy's situation was more than desperate. Under Bellamy's orders, the *Mary Anne* took the lead, followed by the *Whydah* and then the sloop, the *Fisher*. In all likelihood, the ships were simply separated in the confusion of the storm. Regardless, Bellamy's prize galley sailed on to its destruction, for it could not pass over the dangerous bars near the shore.

In those final moments before the ocean dismantled his great ship, Bellamy raised his fists skyward and promised to return to Maria Hallett

even if he had to "sail his vessel over the dunes of the backside to her door." Reynard describes the ensuing destruction as the ship hit the sands:

> *Whether misled by a false pilot, or drunk, or bewitched by Maria... before morning Bellamy lost the silver-heeled Whidah, the Paradise Bird of the Gold Coast, lost her rich cargo of indigo, elephant's teeth and gold dust, lost 400 money bags locked in chests between decks. She was heavy with guns and worn with storm, and the pound of the surf against the bar was intolerable. She turned the bottom up before she broke and her decks fell out.*

Indeed, the scene was horrific, and Maria would have witnessed the last moments of the pirates as they floated lifelessly in the ebb and flow of the raging tide. Barry Clifford, the man who found the resting spot of the *Whydah*, has brought up artifacts and riches from Bellamy's ship, but he has also filled out a narrative of that fateful night through these finds. In his recent book *The Republic of Pirates*, Colin Woodard uses Clifford's evidence to paint the final moments of the *Whydah*'s crew:

> *The Whydah ran aground with shocking force. The jolt likely shot any men in the rigging out into the deadly surf, where they were alternately pounded against the sea bottom, then sucked back away from the beach by the undertow. Cannon broke free from their tackles and careened across the lower decks, crushing everyone in their path. One pirate was thrown across the deck so hard that his shoulder bone became completely embedded in the handle of a pewter teapot. Little John King, the nine-year-old pirate volunteer, was crushed between decks, still wearing the silk stockings and expensive leather shoes his mother had dressed him in...within fifteen minutes the violent motion of the surf brought the Whydah's mainmast crashing down over the side. Waves broke over the decks and water poured into the bedlam of crashing cannon and barrels of cargo below decks. At dawn the Whydah's hull broke apart, casting both the living and the dead into the surf.*

Maria, in her hut on the dunes—whether she caused the storm or not—would have been witness to the mayhem and destruction in the

distant surf. As the sailor's bodies littered the sand in those early morning hours, we can only imagine her frantic search.

Only two men supposedly survived the *Whydah*'s destruction: Thomas Davis, who was forced to join Bellamy's crew, and John Julian, a Cape Cod Indian. As they surmounted the surf in desperate condition, nearly drowned and utterly disoriented, the two pirates somehow scaled the cliffs and probably found their way to Maria's hut. If they did, however, they did not remain there long. Either she had already made her way to the sands below or perhaps she was already busy ministering to other pirates who had beaten them to her path. Some say she even ministered to Bellamy himself.

Historical records indicate that the two pirates made their way to the home of Samuel Harding, with whom they returned to the wreckage site to retrieve treasure. Days later, when the British Crown sent mapmaker Cyprian Southack to the Cape in order to claim the *Whydah*'s spoils for

The advertisement posted by Captain Cyprian Southack as a warning to Cape Codders who had already picked the *Whydah* wreckage. *Massachusetts State Archives.*

A veil on the dunes where Maria built her hut. *Photo by the author.*

England, Harding refused to give up any of his finds for the reason that he was holding the treasure for Davis and Julian, who had not yet been convicted of any crime. Julian disappeared, and Davis was later acquitted of the charge of piracy.

Indeed, the men and women of the Cape had already picked the wreck clean by the time of Southack's arrival, and he returned home with nothing but a cold and a dislike for the inhabitants of Cape Cod. Maria, unlike her neighbors, sought only one piece of treasure initially. Some say that Bellamy's body washed up on shore with the other pirates and that Justice Doane supposedly identified the captain, but many prefer to believe that Bellamy survived. The woman upon whom he swore to gaze again cradled his sea-drenched locks and nursed him in her lonely hut in the early hours of that fateful April morning. Some even say that the pair eventually made their way to Provincetown, where the locals would accept the girl witch and her infamous pirate. There they would live out their final days in peace.

In many other versions, however, Maria remains a solitary figure on the dunes, doomed to relive the final moments when her pirate kept his promise and was stolen by the sea. Perhaps he did survive, but because the price on his head would have been so high, he never let Maria know. Perhaps he did not want to involve the poor girl, for knowledge of his survival might prove dangerous to her. Maybe he sent word to her through a pirate or local who knew of his whereabouts.

In the end, though, her hopes were dashed with the shipwrecking breakers of the Cape. The beautiful Maria Hallett disappeared into her hut with a heavy head and uncertain future, never to look again on the light of day. From that moment on, she transformed into Goody Hallett, the old and bitter woman who haunted the shores of the pirate wreck.

CHAPTER 8

Goody's Gold

From her perch on the dunes, there is little doubt that Maria would have witnessed the *Whydah*'s destruction. And despite the rumors concerning her evil nature, she could not have remained in her hut while drowning men littered the shoreline below. Even if she simply planned to pick the wreck, Maria undoubtedly visited the beach in those early morning hours. While her first care would have been to find Bellamy, she would have encountered more than one hundred other beached pirates along the way. Known as a healer, Maria must have aided those men who washed up on shore.

Like any Cape Codder of the time, she probably planned to salvage what useful items she could from the wreck. At first, she might not have even been aware that the ship was Bellamy's or a pirate ship. She must have slipped down to the shore in the darkness to beat her savvy neighbors.

If she were to find Bellamy's face in the crew, she would certainly have ministered to the man she loved. The chance that he survived seems slight; even if she were to have come across Bellamy, she may not have recognized the drowned man when the sea was finished with his features.

Still, stories survive of men who made it to shore. While all of the pirates who spent the night aboard the *Mary Anne* survived, two from the *Whydah* also survived: the ship carpenter, Thomas Davis, and the Indian, John Julian. All of these men were brought to Boston on charges of piracy,

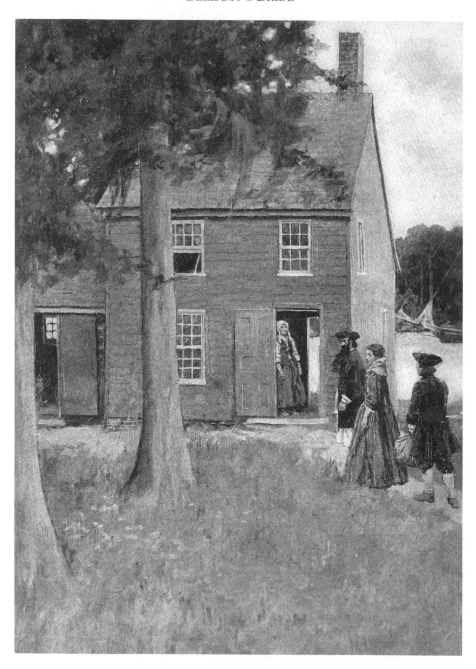

Pirate Home. Howard Pyle.

and so we know for a fact that they indeed survived the storm. But others were purported to have survived as well—even Bellamy himself. If such stories were true, then Maria would have been privy to their nighttime arrival, would probably have tended to them and may have even helped them to bury or conceal the treasure they brought to shore.

The locals certainly believe that Maria, or Goody as they had come to call her, had secret knowledge of Bellamy's treasure and that she spent the rest of her days living off it. These legends are tied to the town tales of surviving pirates who frequented Wellfleet and Maria's cabin.

For sure, treasure made it to the shore. Bellamy's pirates had loaded their pockets with it. The townspeople, practiced at the art of salvaging lost wrecks, lay asleep while pieces of eight first washed up on their beaches. To this day, stories of Bellamy's gold surface. And according to lore, there were pirates who not only survived the shipwreck but also escaped detection and prosecution.

There appeared a story in the February 5, 1980 edition of the *Cape Codder* detailing a confession of "the last male member of a respected Wellfleet family." Apparently, two of his ancestors headed to the wreck site of the *Whydah*. On their way through the woods of South Wellfleet they ran into two of Bellamy's pirates, "who were pretty badly spent from their ordeal in the surf." The pirates swore that they knew nothing of any treasure that had made it out of the ocean's grasp. Not satisfied with the pirates' response, these ancestors tied the pirates to an old anchor on the beach of King's Island. The pirates begged for their lives as the tide was rising, but the two men left the pirates in that desperate situation so they would divulge their knowledge of the treasure. Meanwhile, the man's ancestors left in search of a boat. The tide, however, rose quicker than they anticipated and the two pirates drowned. They deposited the pirate bodies in the surf on the backside. No one knew of their murderous acts, for these pirate bodies washed up with all of the others. For generations, the family members held on to their secret encounter with Bellamy's pirates and the guilt that had haunted their family. Such embellished tales still surface and speak to the fascination we have with treasure and pirates.

A similar tale was told by Jeremiah Digges, who collected many stories of Cape Cod and published them in the early twentieth century. In his tale, a young girl witnesses evidence of the buried treasure:

Ben Eaton's place, the last house at Gull Pond is the spot where two red-coated strangers tethered their horses one night long ago and held a chart up to the moonlight while a scared girl held her breath and peered at them over a window-ledge. They dug a hole there, but whether they had any more luck than you might have, nobody in Wellfleet knows. The tale has come down through generations of folks at Gull Pond, which was something closer to a wilderness then, and curiously the story seems to have escaped the embroidery that hangs in festoons over most of these local traditions. It never reveals whether the strangers really found and took away the gold.

The oldest written tales of survivors, however, point to one strange man who made an appearance in Wellfleet some time after the *Whydah* wreck. The first written account of the stranger appears in 1896 in Charles M. Skinner's *Myths and Legends of Our Own Land*. He refers to this stranger as the "Wild Man of Cape Cod."

Whether the villagers believed that the man was Bellamy, they certainly had no doubt that he was a pirate; they believed he was a pirate who served on the *Whydah* and had survived its destruction. According to town talk, the man knew something about the whereabouts of the treasure. Many of Bellamy's drowned pirates had filled their pockets with riches, no doubt the last act of desperate men before they gave their last breath to the sea. Locals believed that the strange man had filled his pockets as well and hidden what he could.

Though the original account of this pirate provides no physical description, an account written by Charles Swift in 1897 tells us that the stranger was "a man of a very singular and frightful aspect" who used to visit the Cape every season. In 1912, Michael Fitzgerald, a reporter and writer from East Brewster, provided even more detail of the stranger's appearance: "His beard and mustachios were originally coal-black but time had whitened the pointed ends. His face was scarred in many places." Within the narrative of Fitzgerald's tale, a boy encounters this pirate many years later and provides more particulars: "His beard was grey and bushy, growing nearly to his eyes…His nose was large and hooked and there was a fierce glitter in his eyes."

The most specific description of this stranger, however, comes in 1934 from Elizabeth Reynard who gathered earlier oral and written accounts

to formulate a portrait of the stranger that can be no one but the pirate Bellamy himself. She describes him as "a tall stranger…his black hair was streaked with white, his dark eyes commanding…a deep wound scarred his forehead, and his mind was not always clear." She adds that he wore "a gold-button coat and lace at the wrist." The wealthy man was proud and great, though a bit confused, and yet "there was distinction in his highborn manner and his black curly hair. One lock of it, over the scarred temple, had gone winter white."

The pirate's actions are consistent in all of the written tales. He stayed with various families when he came to port; fishermen welcomed the man into their homes. Cape Codders were friendly to strangers, but they also feared the man should they refuse him their hospitality. He would sit by the hearth as tales were told around the fire, but his mind seemed unclear and distant. If the locals grew uneasy or tired of his company, they needed only to bring out the Bible and read aloud from its pages, for it was well known that witches and pirates alike recoiled from the goodness in that book.

Once the pirate retired for the evening, blasphemous words and agonizing cries would be heard from his chamber. Shakespeare tells us that "infected minds to their deaf pillows will discharge their secrets," and it was said that the pirate was likewise tormented by visions of the murders he had committed.

By day, the pirate walked the beach, searching for something. They say he went to the spot where he had hidden his treasure and lifted the loot as he needed it. Others say that he forgot where he buried the rest of his treasure and so constantly combed the beaches in search of the windfall. He preferred to spend his time alone, for he had nothing in common with the locals, though he did depend on their hospitality by night. Some say that the scar on his head spoke of a head injury that had befuddled the stranger so that his later life was a mere mixture of wanderings and nightmares.

After a time, the pirate no longer returned. He did not seek out the hospitality of local families or the cheer of local taverns. People wondered what had become of him, for his strange figure had indeed become familiar to them and their landscape. Many believed that he had gone back to the ocean to pillage on the high seas. But according to lore,

Pirate Ghost. Howard Pyle.

the man did not leave the town of Wellfleet—he had simply relocated to the dunes, to a lonely hut just like the one in which Goody Hallett stayed.

As the stories go, one evening a traveler was passing by those very dunes when he heard the familiar cries of the pirate. Now, the man, just as all of the people in Wellfleet, was used to the pirate's evening cries, for they knew that the man was tormented by the evil deeds he had performed at

sea. The frantic pleas of the pirate, therefore, did not alarm the traveler, and he quickly hurried from the unsanctified place. It was not until the following morning that the people found the stranger. The earliest story goes that "the wild man lay still and white on the floor, with the furniture upset and pieces of gold clutched in his fingers and scattered about him. There were marks of claws about his neck." Apparently Goody, too, wanted a share of the gold. It seems unlikely that she would murder the man for whom she had waited so many years. Perhaps the man wasn't Bellamy after all but rather another pirate from whom Goody wanted her due.

In some tales, the manner of the pirate's death is not described, while in other tales it is told that his body was simply found on the beach. The one consistent strand in all of these legends, however, is that the man was found with a girdle full of gold. That belt confirmed the people's suspicion of his origins.

Elizabeth Reynard, however, adds a romantic twist to the stranger's final days. As evidenced by her physical description of him in *The Narrow Land*, she believes him to be Bellamy. She places him in the very apple orchard where he first met Maria many years previously. Dazed from the

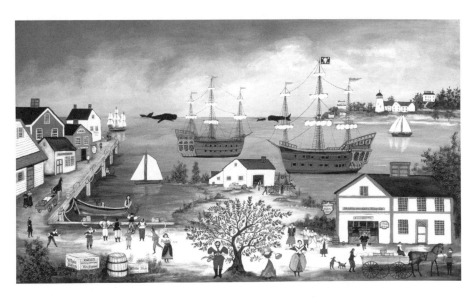

Sam Bellamy and Maria Hallett, Janet Munro. *Janet and Charles Munro.*

destruction of his prized ship and the years since, Bellamy wanders to the old orchard looking for Maria, never knowing that she had become an outcast on the dunes:

> *He died in the summer of 1720 in the apple tree hollow by the Burying Acre, where he went so often and seemed to be waiting for someone. After he was carried to Higgins Tavern, a belt of gold was found on his body; and the men who looked at his face in death said that it was brave and young.*

While some legends assert that an anonymous pirate survived the wreck only to perish at the hand of Goody Hallett, it seems better to believe Reynard's version. Perhaps Bellamy did return to the very orchard where he and Maria had first fallen in love a mere five years earlier. The short span of time had taken its toll on both of them; their hair had gone white with the agony and stress of the horrors they endured. They longed to return to that place of innocence when riches and love were before them for the taking, to the garden where love was new and eternal. How fitting it is, then, that Bellamy may have returned to that very spot to end his days on this earth.

The Death of Goody Hallett

G oody Hallett's death is inextricably tied to the strange man in the previous chapter. Again, whether she was a wrathful witch or a devastated girl largely depends on the legend you choose to believe.

Michael Fitzgerald, a Cape resident who collected oral tales at the turn of the twentieth century (and on whose notes Reynard relied in her writing of *The Narrow Land*), is the first to provide a specific account of the stranger's encounter with Maria Hallett and his part in her death. In Fitzgerald's version, his character, Uncle Jabez, is a mere boy when he hears the story from a visiting minister.

In those days, as previously stated, Cape Codders took friends and travelers alike into their homes and provided them with refreshment and warmth. They sat around the crackling fire and shared their stories from that day or days long past. A true Cape Codder practiced the art of embellishment, as his guests or hosts leaned in a little closer to listen to his marvelous tales. And so the narrator of *1812: A Tale of Cape Cod* describes his Uncle Jabez, who sat by such a fire one evening when a visiting minister was in need of hospitality and hearth. In turn, the minister shared a fantastical tale of his experience with Goody Hallett and the strange pirate.

Some time before, the minister was traveling through the lonely dunes set against the eerie backdrop of nightfall when he came upon Goody Hallett's hut. Since he knew her reputation as a solitary spinster, he was

surprised to hear angry voices coming from the spot. The voices belonged to Goody Hallett and a pirate.

The pirate refers to Hallett as "Mother Hallett"—an interesting choice, as the term "mother" was generally reserved as a respectful title for an elderly woman. If the pirate were indeed Bellamy, he would certainly have chosen a different name for the woman he once loved. As the story continues, though, the strange man all but reveals himself to Goody as the black captain of the *Whydah*: "They thought they buried me with the rest of the gallant rovers when the ship went to pieces under us, but they little knew who was the fellow-survivor of your relative, Indian Tom."

Apparently, Indian Tom helped Bellamy hide from the wreckers and authorities. They lived off the land, and Bellamy disappeared while Indian Tom hid the treasure. According to records of the day, Indian John Julian did disappear, but scholars believe that he was sold into slavery. All of the other pirates were supposedly accounted for, though they could not have truly known how many men were on the ship.

Maria refers to the man as merely "pirate"—again a nondescript title for the would-be man to whom she dedicated her entire life. She swears that Indian Tom told her of the treasure's location on the night of his death and that she found only a small portion of the treasure there, implying that the bulk must have been hidden in another spot.

As a consequence of the rum Goody served him or the disgust he felt at the old woman's betrayal, the pirate accused Goody of murdering Indian Tom so that she could be the sole keeper of Bellamy's treasure. Goody became indignant at the idea that she had something to do with her nephew's death, and the pirate realized that he had pushed the old woman too far. He proceeded to sing a raucous song to cheer her spirits:

> *Sing, ho, my lads, for Bellamy bold,*
> > *For he is king of the main!*
> *He's filled the hold with yellow gold*
> > *From the galleons of Spain.*
> *Then bear away by the light of the moon,*
> > *We carry a rover's freight—*
> *Sing ho, for the gleam of a yellow doubloon*
> > *And the chink of pieces of eight.*

The remaining verses sing to the many women, both the fair-haired of the coast and the dark-hued of the south, with whom Bellamy had spent his nights. Evidently, the song lightened Maria's mood, which seems very strange considering she was one of those fair maidens who carried his child and suffered so greatly for her loyalty to a man who, according to the song, was no more than an unfaithful rover.

Maria's actions are also curious, for she seems to care more for a treasure than she does for the pirate before her. She also seems to be withholding information about the spoils. Either she already took a large share of the treasure and moved it, or as she told the pirate, the sea and shifting sands had dispersed the booty. At any rate, the man believed her and promised to return after his next sea adventure, when they would search for the treasure together. All became quiet, and the tall woman and strange pirate seemed to have reached a satisfactory agreement. The pirate then left for Boston, from which he was planning to sail the next morning.

After leaving the dunes, the minister told his friend, the Reverend Avery, of his nighttime encounter. The two traveled to Goody Hallett's hut the following day, but she denied the pirate's presence or any altercation. Surely, she would not divulge the details of the meeting because the pirate was already encroaching on her treasure. She didn't want others to lay their claims to it as well.

Now, this strange relationship between Maria and the pirate can be explained in two ways. First, Bellamy and Hallett, having been hardened by experience and betrayal—he with other women and she with concealing treasure—recognized that they each needed the other in their avaricious endeavors. Though neither really trusted the other, they were forced to work together for the sake of gold and silver.

A likelier explanation, however, is that Goody Hallett was a woman far older than Bellamy and that they never had a romance. And the odd woman, likely a witch, was privy to the location of the *Whydah* treasure because of the location of her hut by the site of the wreck and her relation to Indian Tom. The pirate's song cheers her because its lyrics link the greedy woman and the greedy pirate. Indeed, the only way that the next part of the tale makes any sense is if there had never been a romantic liaison between the two.

As the tale continues, many years later, on a cold night in early spring, Jabez and his mother were alone in their house. Jabez was by this point the man of the house when a stranger came knocking at the door. Though the stranger was older and more civil than the stranger of whom the minister spoke so many years before, Jabez was sure that he was the same pirate from the minister's story.

The next day, Jabez was sent by his mother to Goody Hallett's hut with a bundle of wool for the woman to spin. Jabez was surprised to find that no one answered his knock, for Goody Hallett rarely left her hut in the daylight hours. Jabez had arrived in the early afternoon.

Jabez tied up his horse and left his bundle of wool on the doorstep. He wandered over to the dunes while he waited for Maria's return, for he was determined to finish his errand. While he sat looking out over the ocean, his concentration was broken by a bloodcurdling shriek, and though frightened, he peered over the cliff to find the origin of the hideous sound. There lay the body of Goody Hallett, her throat cut from ear to ear, while the same strange pirate stood over her with his foot on her chest and pressed his dagger into her lifeless heart. And then he heard the pirate utter the following words:

Accursed hag! Lie there for the birds to peck at! Sam Bellamy's knife has stung better women than you and death at his hands is too noble an ending for your life of deceit. Sam Bellamy's own time has come, but he will get release from his troubles beneath the waves which he has ruled and on the spot where his gallant shipmates met their fate! Fare ye well, old witch!

True to his word, Bellamy washed up days after Goody Hallett's death on the same shore where the *Whydah* pirates had washed up so many years before.

The locals searched Maria's cabin for some sort of evidence that could provide them with a motive for the pirate's murderous actions, but they found nothing more than a few gold coins. After their investigation, they set her house on fire. Even the remaining ground sent shudders through passersby for years to come. The townspeople suspected that the pirate killed Maria for taking and hiding his treasure.

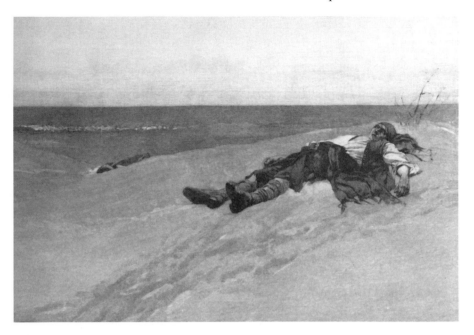

Dead Pirate. Howard Pyle.

Once satisfied, he took his own life in the manner in which he should have lost it that night in April 1717.

Almost three decades after Michael Fitzgerald's story, Jeremiah Digges, another collector of Cape Cod's lore, tells a similar version of Maria's death. This time, the Reverend Osborn, a man who did serve the people of Yarmouth, was purported to have overheard the violent argument between Goody Hallett and the pirate stranger, who was indeed Black Bellamy. Rather than rejoice at their long-awaited reunion, the witch and the pirate made devilish deals in her cliff-top cabin.

In this version, too, Bellamy accuses Hallett of stealing his treasure, and she again assures the pirate that she knows of only a few pieces of gold, which have barely kept her alive in the intervening years. Digges does, however, refer to their earlier romance, giving more credence to the possibility that she is Maria. Bellamy finds Maria's physical change revolting and harbors no romantic feelings for the witch. He distrusts the fallen woman and forces her to divulge Indian Tom's hiding spot.

Here, too, Maria is adamant that she knew nothing of the treasure or of Bellamy's survival until the night Indian Tom died. She never divulges

the secret spot in which the treasured is buried, though keeping the spot secret is certainly advantageous to Maria as well.

She leads Bellamy to the shore, while Reverend Osborn hides and listens to their talk. Bellamy forces her to dig for the rotting leather pouches and the few coins they hold. But once she uncovers the measly remnants of the *Whydah*'s hold, Bellamy cuts her throat as a lesson to the old hag for trying to deal double with a pirate as great as Bellamy. He leaves her there on the shoreline that she had so often traveled in search of his sails.

After her funeral, the townspeople searched the forests of all the bordering towns for Hallett's murderer, but with no luck. Five days later, however, Bellamy's body washed up on the same shore where Goody Hallett met her fate.

About the same time as Digges published his version of Maria and Bellamy's deaths, Elizabeth Reynard published her collection of folk tales. While she includes the latter version, she also adds another. And just as she chose to provide a fitting death for Bellamy, she likewise alters Maria's violent end in a manner fitting with the romantic nature of her earlier relationship with the pirate.

In this version, Thankful Knowles—daughter of John Knowles, the man whose barn served as a hiding spot for Maria's newborn son—travels to Maria's hut in search of a pattern:

> *The witch girl was not in her hut, and knowing that she was wont to sit on a ledge by the sea where the Whidah lay,* [Thankful] *ran, stumbling, breathless, across-dune to the town. For Maria Hallett, dressed in hyacinth blue, with at least a thousand apple blossoms woven over the skirt of her gown, lay stiff on the ledge, her eyes shining, a gash across her white throat and a stained knife in her hand.*

Unable to live on this earth once the brave Bellamy ceased to walk it, Maria took her own life. Eleanor Early tells a similar tale in her 1936 book *And This Is Cape Cod.* Here Maria ends her life much earlier, however, directly after the *Whydah*'s destruction. Early dismisses the notion that Maria was a witch and pities her tragic end: "She spent her whole life on the cliffs of Nauset, watching for her lovers' return. And when he was

shipwrecked, Maria cut her throat, which was something no witch would do—but only a mad creature"; mad with love, for which she gains Early's sympathy and understanding.

Though the legends of Maria's death differ, one part remains certain: she dies violently at her own or her lover's hands. The treasure that was supposed to secure their future destroyed their lives.

CHAPTER 10

Fuel for Folklore

As a new day descended on the devastation of the *Whydah* and its crew, stories of the storm traveled the long arm of the Cape. And Maria, never free from the people's chatter, played the starring role yet again.

Everyone knew that Maria had made a deal with the devil in Eastham the year before. With the flick of his gold-tipped cane, the cell bars gave way and the girl gained her freedom. But Maria longed for more than her freedom. They say she longed for revenge on the sailor who led her to sin and left her with child. They say she sold her very soul in exchange for Bellamy's death.

The magnitude of the storm that took Bellamy's life fueled the fantastic tales that surrounded his death. The nor'easter was unparalleled in Cape Cod history. Certainly, the elders and dames alike argued, the fiend himself commanded the winds that evening or endowed Maria with the power to brew the storm herself. If God had gathered the gale that forced the magnificent *Whydah* to the ocean floor and punished Black Bellamy for his days of murder and avarice, then the people said that Maria sought her revenge on God himself. Either way, they believed that the poor girl was in league with the devil, and they filled their evenings with talk of the dark arts she performed on the dunes.

Soon enough, people began to believe that Maria was a powerful conjurer in her own right. Certainly the mighty and devastating storm

that claimed the lives of more than one hundred pirates was evidence of her potency. Tales of her sorcery instilled great fear in the people who had previously punished Maria. They say that even the horses quickened their paces as their hooves crossed her lonely hut on the dunes.

The beautiful Maria, though, with her golden hair and cobalt eyes, didn't really fit the people's idea of a sea witch, and so perhaps the people dropped Maria's given name and simply referred to her as Goody Hallett. The terms "goody" or "goodie" were often used for a married woman, but people also used them as nicknames. And with the new name came new descriptions of Maria. The Goody Hallett, now referred to by the townspeople, did not resemble Maria in the least; her transformation was as great as the storm that had claimed Bellamy's life.

They say that her long and fine blond hair grew stringy, coarse and gray. Her eyes—the eyes that had once entranced every Eastham boy— turned dull and dark. Her tall and lithe figure melted into the little old frame seen so frequently on the dunes. And as the years passed, her delicate skin sallowed and creased. Indeed, in a matter of years,

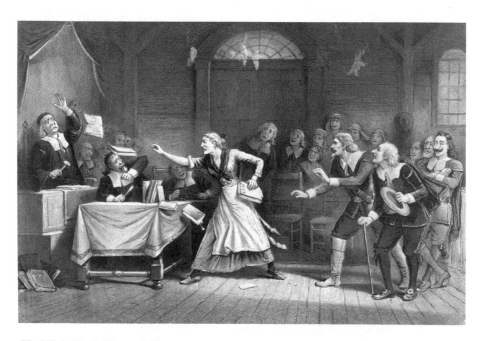

The Witch, No. 3. Library of Congress.

Maria Hallett was replaced by Goody Hallett, the witching woman who haunted the Cape.

One of the most popular images of Goody Hallett involves her lantern, for she was always seen holding the lantern high over the cliffs. She was even said to carry a drip-rush lantern in the days of her innocent youth. The story of her lantern is interesting because it comes from a place of truth, though the truth had little to do with Goody.

You will remember that Bellamy had asked Robert Ingols to guide him safely into the harbor on that fateful April evening. There were no lighthouses in those days, and the Cape shores were dangerous, storm or no storm. The captain agreed to put out a lantern, but legends assert that he used that light to lure the *Whydah* to its destruction. Soon enough, the townspeople turned their talk to Goody and away from the captain of the snow; his actions were practical, while Goody's could be magical. They say it was she who stood on the dunes that evening and held out the lantern to destroy her false lover. She screamed curses that were louder than the gale-force winds. The ultimate mooncusser, she destroyed the bird of the high seas with one lantern.

The stories did not stop with Bellamy's ship, though. They say that after Bellamy's death, Goody poured her wrath on all sailors and conjured special storms to dismantle their ships in the surf below her hut. They say that Goody could never forgive the sailor who had deceived her, and so she wreaked havoc on sailors in general. She lured them to their deaths with her lantern time and time again, and then she picked their wrecks and cursed their souls.

While the people endowed Maria with supernatural powers during her lifetime, tales of Goody's wickedness increased after her death. Her mortal powers paled in comparison, and sailors often encountered her while they struggled with the seas and sandbars off Cape Cod. The people told of her familiars, the same black goat and black cat attributed to the sea witch of Billingsgate. Cape Codders know their tales, and any reputable witch must be outfitted with familiars. These animals aided Goody in her nightly endeavors. Reynard tells of their escapades as the three of them rode on the backs of dolphins along the outer reaches of the Cape and into the Grand Banks. She tells how the sailors would recognize the glow of Goody's green-eyed cat. Immediately, they would yell out to one another, "That be Goodie Hallett's familiar waitin' to pick up souls. Reef sail, a

squall's to winward!" And Reynard also tells of their speech in contrary winds: "The old woman has got the cat under the half-bushel."

Goody even commanded the greatest beast in the sea, the whale itself. They say Goody, like Jonah, occupied the belly of a whale for more than a century. But while Jonah's experience was biblical, Goody's was evil. Indeed, as Reynard tells it, she was invited to live in the whale by none other than the devil:

> *Goodie and the devil sat night after night, comfortable and warm, drinking hot rum and dicing for souls in the "front parlor" of the "whistling whale." She hung a ship's lantern on the tail of her leviathan, and drove him among dangerous reefs. Vessels, seeing another ship safely in course, followed these lights and were wrecked, or marooned on the bars.*

They say the devil grew tired of Goody's winning streak and eventually strangled her. Others say that Goody shape-shifted into the form of a whale while the devil rode her through the waves.

As if dicing with the devil were not sinful enough, Jeremiah Digges adds in the old woman's sexual exploits:

> *Now and then she selected a strong, good-looking young fo'mast hand for other kinds of "divarsion." For Goody, in her later years, had become a deep-dyed sinner, whom you would never have taken for the blossoming maid, once the pride of the hymn-singing Hallett's of Eastham town.*

Soon enough, the townspeople blamed Goody for a host of misfortunes. While her maritime exploits included hurricanes, shipwrecks and drownings, she spent her time harassing the landlubbers as well. They blamed her, among other things, for their failing crops and unexplained illnesses.

Though many of the Cape residents took advantage of the *Whydah*'s wreckage, and whatever treasure made it to the shore, they knew in their hearts that they had been cheated out of the bulk of the booty. Of course, they blamed Goody again. Though they say that she never had need of spoils, for she lived simply enough, they say that she buried the remaining treasure. She took from it only as she needed it for her daily living. Of course, no one ever found the treasure in those days, and they could easily explain the

reason. Goody, as she grew old and her faculties began to wane, forgot where she buried it. When she died the secret died with her, and her specter had no need of the silver cache. And so Bellamy's treasure disappeared forever.

The people also swore that they heard Goody Hallett's cries during raging storms. In fact, one of the most consistent strands among the versions is the tragic image of Goody wailing into the darkness. Either she cursed Black Bellamy for the agony he had caused her or she mourned his loss and loved him still. Whether she cried out in revenge or agony, sailors and townspeople alike spoke of her screams.

Some say that Goody had remained faithful to her pact with Bellamy. Like a dutiful woman, she waited for his return and longed for the day when they could legitimize their love in the meetinghouse. They say that she was there that evening and held the lifeless and bloated body of her lover in her frail arms, just as she had held their dead child months before. Poor Goody had only been a foolish girl, and she did not deserve the tragedy that had been visited upon her; therefore, she was doomed to walk the shores and bemoan her fate forever. And you would, too.

Various words have been used to describe her nightly agony—screams, wails, cries and shrieks alike echoed in the ears of Eastham and Wellfleet residents. Her lamentations loomed as far as Provincetown. The people said that poor Goody danced with the other souls in the meadow by her hut, for some still believed that she dabbled in curses, yet they pitied her all the same. Reynard tells that "the tavern gatherers, when they heard a shriek mingling with the high sea wind, drew their cloaks about them and murmured, 'Thar be pore Goodie, dancin' with the lost souls.'"

Perhaps because they grew to pity her, or perhaps because they admired her fortitude in the face of extreme adversity, some people began to tell a different story of Goody's ghost. These men and women told a quieter tale, for they gave the witch and the pirate the ending that life had denied them. They said that on foggy evenings, one could make out the figures of Maria and Sam walking hand in hand along the shores and meadows of the Cape. No one surmised the content of their talks, for the two tragic figures had forged a tie in life that bound them forever.

So if you hear the forlorn cries of a woman in the howling night, or you spy two figures strolling in the foggy mists of Cape Cod, know that you have perhaps witnessed the ghosts of Sam Bellamy and Maria Hallett.

Of Witches and Natives

Before we try to pinpoint the name of the girl that the legends refer to as Maria Hallett, we need to first look at her origins. As previously stated, some people suggest that Maria was the daughter of a witch hanged in Salem during the infamous hysteria of 1692. We can take a closer look at the women who were executed during that dark period in American history. Most of these women were established and respected members of their communities, and many either hailed from prosperous families or owned large portions of land (a fact that some historians have linked to the cause of their indictments).

All of the fourteen women who were convicted and hanged of witchcraft had children. Two bore only sons. Sarah Averill Wildes was the second wife of John Wildes. While he had eight children with his previous wife, Priscilla, records indicate that he and Sarah had only one child, a son named Ephriam. Martha Corey, whose husband Giles Corey was pressed to death for refusal to respond to the charge of witchcraft, was said to have had an illegitimate son prior to her marriage to Giles. The boy, thought to have been mulatto, may have contributed to some of the accusations against Martha.

Many of the remaining women's children would have been much older than Maria in 1715. Bridget Bishop's daughter, Christian, had already been married for five years by the time her mother was executed in 1692. Susanna

Martin's daughters, all born in the 1650s, would have been in their sixties. While older women have been known to work their wiles on younger men, I doubt Bellamy would have been seducing women forty years his senior! And these women would certainly have been past the age of childbearing. Though convicted Ann Pudeator did capture herself a man twenty years her junior as her second husband, her daughter (Ruth) was from her first marriage and born about the same time as Martin's daughters. Again, Margaret Scott's children, very few of whom made it to adulthood, were born prior to her husband's death in 1671. And Wilmott Redd, though her children are not well documented, was born in the early 1600s.

Many of these children mentioned went on to marry and have documented families of their own, thereby making the possibility of their being Maria Hallett slight. Sisters Rebecca Nurse and Mary Eastey both had large and supportive families. Rebecca had many daughters, but they were all born by 1655. Though Mary Eastey also gave birth to at least three daughters (Mary, Abigail and Sarah), they were again too old to have been Maria Hallett.

Elizabeth Howe's daughter, Deborah, would have been only thirty years of age in 1715, but she was already married to a cousin, Isaac Howe. She appears in a 1712 court document when she receives restitution for her mother's death. Elizabeth's other daughters—Elizabeth, Mary and Abigail—were all born prior to 1674.

Maria Carrier had at least two daughters, the younger of whom, seven-year-old Sarah, was put in jail and tortured until she gave over evidence concerning her mother. Sarah Good gave birth to a girl while she awaited execution, but the infant died. Sarah's five-year-old daughter, Dorcas, was also accused of witchcraft and jailed. She was later released. Mary Parker had at least four daughters, the youngest of whom was born in 1670. Alice Parker remains mysterious, and her family is not well documented.

Though there is certainly the possibility that Maria could have been the daughter of one of the accused who died in jail, it is unlikely that she is the child of one of the executed. The rumor, however, makes sense. Maria was thought to have been a witch herself when the hysteria of the witch trials over in Salem was still cooling.

Therefore, a mere twenty-three years later, rumors continued to circulate about witches. With Salem's proximity to the Cape, the people

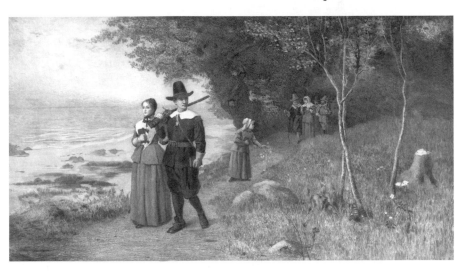

Pilgrims Holding Bibles Walking Down Path. Library of Congress.

of Eastham connected Maria to her Salem counterparts. They never formally accused her, for they were not so quick as to condemn a woman or man to death over the issue of witchcraft. They did, however, enjoy a good fireside story, and many had already determined in their own hearts that Maria was indeed a witch.

In addition, Maria was said to have been a wild spirit, outspoken and strong-willed. Many of the women hanged in Salem were known for similar traits. They laughed at their accusers, questioned the sanity of the court and protested their innocence until the very end. Maria, who was "wild as Nauset wind," did not care for the talk of the townspeople, before or after her courtship with Bellamy. Also, after the death of her child, Maria was said to have "lost her mind." Such women, especially if they had sinned, were deemed suspicious.

Another theory surrounding Maria's origins is that she was a member of the Nauset tribe or that she intermarried with one of the natives. The Nauset Indians lived on Cape Cod and, particularly, in Eastham and Yarmouth during Maria's lifetime. In fact, Cape Cod was originally named Nauset, or "place of the bend." At the turn of the seventeenth century, white men renamed the peninsula Cape Cod.

The number of Nauset Indians in the area of Yarmouth to Wellfleet had already begun to decline due to sickness as early as the 1600s. In

1710, an epidemic brought their numbers down to about three hundred. Reverend Samuel Treat, so often mentioned in Hallett and Bellamy's story, worked hard to convert these natives. He even learned the Algonquian language and delivered masses to them in their own tongue. He often visited the Nauset and took part in their celebrations. For these reasons, he earned their trust and even their love. When he died, during a great winter storm in February 1717, his home was encircled with feet of snow. It took days before the people could dig a path to his door in order to remove his body. The Nauset carried Samuel to his grave in a final show of their respect for the man.

Whether the white men respected the Nauset is another question altogether. It seems that the more the "praying Indians" converted to English dress, manner and custom, the more "respect" they earned from their English neighbors. With the small number of surviving Nauset, they were subject to the larger Wampanoag tribe who lived in present-day Mashpee. The Nauset were disappearing not only to disease; the Indians converted to the ways of the settlers, and their culture began to disappear altogether.

The new inhabitants of Cape Cod feared the wild nature of the natives, even after they outnumbered their Indian neighbors. In fact, hunting laws of the day indicate the unfairness with which the white men treated the natives. The settlers feared that the devil was building an army of witches from their very ranks, and they also feared the soulless Indians and their black arts.

It is only natural, therefore, that they would start to believe that Maria was not only a witch, but a native as well. Many of the Nauset and Wampanoag intermarried with black and white settlers alike. While the practice was not condoned, it was reality. Also, the Wampanoag and Puritan beliefs differed concerning sexual relations prior to marriage. Once the natives chose a marriage partner, however, they were to remain faithful; though some tribal leaders took more than one wife.

After Sam Bellamy's death, the rumors of Maria's Indian heritage began. At that time, Maria lived alone in her hut on the dunes and traded with the few people who would still deal with her. Fitzgerald describes her as "a tall, thin woman, with dark features strongly telling of Indian blood." In his 1937 piece on Goody Hallett, Oliver Knowles repeats

this theory: "Her features became dark and forbidding, her silky blonde hair grey and stringy, and gossip began to tell of her Indian ancestry." A purported survivor of the *Whydah* was Indian Tom, who was also said to be related to Maria. In one particular legend, in which Bellamy accused Maria of killing Indian Tom to keep the pirate's treasure for herself, she reacts indignantly: "Dog of a pirate! Dare you insinuate that I had aught to do with the death of my uncle's son?" Whether Indian Tom was indeed a legitimate or illegitimate cousin of Maria Hallett remains to be seen, but the rumors of her Indian ancestry were certainly widespread.

Some believed that Maria took up with Indians. Jeremiah Digges has asserted that Maria was seduced—not by Bellamy, but by an Indian. He did not describe Bellamy the way other writers of the time described the pirate. In fact, he doubted that such a man could seduce any Cape woman, never mind the most beautiful girl in Eastham:

> *As the record shows, Sam Bellamy was a simple, blustering windbag of a fellow, and a furriner at that; and I doubt if he was capable of the uncommon finesse it wanted, to trick the prettiest girl in a Cape Cod town. It wants a mite of doing to win one of these creatures, and in the version I have heard of Goody's first fall, it seems to me that the native touch was present.*

Whether Digges is using the term "native" to refer to a man born on Cape Cod or an Indian, additional sources assert a relationship between Maria and the Indians. They say that Maria, well after she had become an established witch, married a Wampanoag from Mashpee. Reynard recounts one of these tales in her book *The Narrow Land*:

> *Landsmen say that Goodie the witch married an Indian from Mashpee, a praying fool who did not know that she was in league with the devil. One night, when he came home late, he found Satan in the form of an imp, suckling at a witch teat on her breast. He tried to fling the Evil One away, but the devil clung, and Goodie cried out against her husband. What could the Indian do? He wanted to save his wife and he knew that imps could not stand water. He picked up his wife, devil baby and all, and flung her into the sea.*

In these versions, the Indians are shown to be either tricksters or fools, which tells us much about the settlers and their relationships with the native people of Cape Cod.

Interestingly enough, the legends of the Wampanoag also deal with witchcraft, and their tales parallel the settlers' tales of Maria. Elizabeth Reynard worked tirelessly to gather many of the native myths of Cape Cod, and luckily, through her research, these tales survive. In the old native tale "The Screecham Sisters," two sisters, Hannah and Sarah, had a falling out. They then moved to different areas of the Cape. Hannah remained on Grand Island, off Cotuit, while Sarah made her home in Mashpee. These evil sisters tortured the early people of the Cape. While Sarah served the devil as a witch, Hannah dealt with pirates and their treasure. Every pirate, including Captain Kidd and Sam Bellamy, knew Hannah, and she knew the secrets of their hidden gold. Just as the people believed that only Goody Hallett was privy to the secret hiding spot of Bellamy's treasure, the Screecham legend insinuates that Hannah worked with Bellamy, too. A part of the tale, recounted by Reynard, describes her dealings with pirates:

> While a pirate sloop lay offshore, the captain flew signals to Hannah. Then a boat put out from the pirate ship, a boat with the captain and one sailor and a treasure of Spanish pieces of eight…or perhaps bars of bullion, or caskets of jewels from Spain. Hannah went down to the sea beach, kissed the captain, and nodded to the sailor. The captain gave her a shawl, or a locket of hair, or a finger ring. At her direction, the sailor carried the treasure into the interior of the island where a deep pit had been dug. When the last bar was laid in place, and the last coin safe in its box, Hannah pushed the sailor into the yawning pit. Quick-running sands seeped over him, and he was buried alive. Then she screamed like the gull in storm, a cry that mingled with the wind in stunted trees, or the waves shrilling on the outer beach. At that signal, the Captain put back to his ship; and even the Black Bellamy, cruelest of buccaneers, shivered as he heard her wail. Yet he knew that his treasure was safe, its whereabouts known to only two, Hannah Screecham and himself.

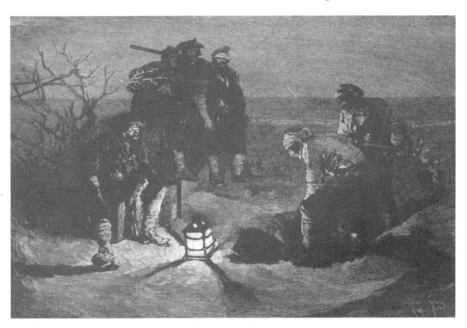

Pirates Burying Treasure. Howard Pyle.

Hannah's tragedy was that even though she knew where the gold was hidden, she was never able to take any of it; if she tried to steal any of the gold, the sands of the Cape would open up and all of her dead victims would raise their spectral hands from the earth and choke her to death. They say that her shrieks still echo over the waters of Grand Island and that she is warning pirates that someone is after their gold.

Her sister Sarah haunted the land of the Wampanoag in Mashpee. She forbade any man to hunt, though game was certainly abundant in the area. She was able to shape-shift—as many witches, including Goody Hallet, were wont to do—and she often took the shape of the deer that populated the area. Eventually, she fell in love with a man who, instead of returning her affection, attempted to capture her. One day, she allowed the man to take her. She had shape-shifted into a horse, and the man affixed horseshoes to her hooves and tied her outside. Soon enough, she disappeared. The man later found Sarah, "a silver horseshoe nailed to her left palm." Years later, when she appeared as a young doe, a swift Indian shot her through the heart with a silver bullet.

Surely, the legend of Goody Hallett shares much of its lore with the legend of these sisters. First of all, she was said to hold the secret to Bellamy's treasure. Her cries also echoed the gull's cries in the wind. And like Sarah, Goody Hallett was a witch who fell in love with a man. Due to tragic circumstances, she also lived alone and later died from a wounded heart.

The Halletts of Yarmouth

According to folklore, Maria hails from the Cape town of Eastham. The Hallett family, however, is rooted in Yarmouth at the time of Maria's birth. Some legends state that Maria hailed from Yarmouth but later settled in Eastham. Either way, if we look at genealogical records, Maria either was born into or married into this Hallett line. As Yarmouth and Eastham were not a great distance from each other, it is certainly feasible that the Yarmouth Halletts were Maria's kin.

The Halletts were a prominent and wealthy family who served their community in various capacities. The patriarch of the family, Andrew Hallett, was born in England, probably in Dorset sometime between 1590 and 1607. Though he settled in New England as early as 1635, he lived in Lynn, Plymouth and Sandwich before moving to Yarmouth. At that time, we find two Andrew Halletts living in Yarmouth, and historians and genealogists differ on the two Hallett lines. Some believe that these men were cousins, while others believe they were father and son. Either way, the earliest record we have is a grant from November 1639 in which an Andrew Hellot (various spellings were common for names and words, even within the same document) purchased a tract of land in Yarmouth:

Memorand, That Thomas Starr of Duxberrow doth acknowledge that for and in consideration of the Sum of tenn pounds sterl. five pounds

wherof is in hand payd & the other five pounds is to be payd the xxvth of March next by Mr. Andrew Hellot of Plymouth both freely and absolutely bargained and sould unto the said Andrew Hellot one frume of a house with a chimney to bee set up and thacked in Yarmouth in the place appointed and seventeene aereas of Marsh & meadow onto the said house and mead., stud belonging in Yarmouth aforesaid with all and singular th appreten'es thereonto belonging and all his right title & interest of & into the same with evry., & pcell therof. To have and to hold the said house & meadsted seventeen acres of upland and twelve acres of Marsh & meadow with all and singular th app'tencs thereunto belonging unto the said Andrew Hellot his heirs and assigns for evr to the only ppor use and behoofe of the Said Andrew Hellot his heirs and assigns foeur. The frame of the said house is to be made & set up with a chimney and to be thatched studded and latched (daubing xcepted) by Willm Chase who was agreed wth all and payed for the doing thereof to the sd Thomas Starr before the bargaine was made with Mr. Hellot as Aforosd and so assigned out to him.

Again, in 1642, an Andrew Hallett purchases a home and ten additional acres of land. It seems to me that Andrew Hallett Jr. probably purchased the second tract of land after the family moved to Yarmouth in 1639. They were both living in Yarmouth by 1643, for they show up in the town records as "liable to bear arms." Andrew Sr. dies by the year 1647. While he had accumulated little wealth, we know he was a man of property. He stands out from the factual deeds, suits and wills of his day for a kind donation he made upon his death to the people of Yarmouth. He bequeathed a cow to the poor of the town as illustrated in the early Plymouth Colony records:

Whereas information is given to the Court that there is a cowe or a heifer in calve given or disposed by Mr. Andrew Hallett, Sen., of Yarmouth, for the benefit of the poore of the said towne of Yarmouth, which for the ordering thereof was referred to the Court by the said Mr. Hellot, by his letter under his hand, bearing date the first day of March, 1643.

In his 1890 book *Genealogical Notes of Barnstable Families*, Amos Otis reflects on Hallett's generous action:

*His generous donation to the poor of Yarmouth will ever be remembered,
and make us regret that we know so little of the man…In order to form
a just estimate of the value of the gift, it must be borne in mind that
cattle were scarce in the Colony, and that a cow was then the equivalent
of a good sized farm, or of the wages of a common laborer for a year.*

While we know little about Andrew Hallett Sr., we know quite a bit about Andrew Hallett Jr., for he was one of the wealthiest landowners in Yarmouth. Indeed he owned more than three hundred acres of land between Yarmouth and Barnstable alone. This Andrew is believed to be the ancestor of all the Yarmouth Halletts to date. If Maria is descended from these Halletts, her family was certainly noteworthy and well-to-do, a fact that would have increased their shame over Maria's inappropriate relationship with Bellamy.

Andrew was active in the young town, for he worked in various positions from 1642 to 1679. He served as a surveyor of highways, a constable and a grand jury member. He is even noted as a schoolmaster at the time of his death in 1684, though there are no other records to confirm his position. The schoolhouse did, however, border his property, and his son, John, was part of a group appointed to find a "fit person to teach school."

Maria's supposed ancestors were not exempt from their own scandals. Andrew married Anne Besse (or Bessee or Bearse) when she was only fourteen years old, and while her age was not in and of itself unusual for marriage, the girl was young of mind and heart. Anne would have been Maria's grandmother, and she and the women in her family were known for their willful and strong ways. The old story goes that Anne, at age fifteen, gave birth to twin girls, Ruhama and Abigail. Her mother, only thirty years old herself at the time, assisted at the birth. The following day, Anne left her mother to watch the twins while she went out to look for bird's eggs. Some believe the story illustrates Anne's immaturity. The neighborhood men, in fact, laughed at Andrew's child bride and her strange and headstrong demeanor. Andrew wasn't sure what to make of his new wife, whether her actions illustrated strength or folly. To be sure, her female descendants would prove equally troublesome and curious. The Hallett family appears in more than one story in Old Cape folklore.

Andrew and his daughter, Mehitabel, figure prominently in a story that may as well have been written about Goody Hallett herself.

In the beginning of the story, Andrew peers in on his youngest daughter, Mehitabel, while she is sleeping. He worries over her, not simply because she is his child but because of her wild nature. Reynard writes of Andrew: "He closed his eyes with a sort of physical shrinking when he thought of hellfire for Mehitabel, yet he honestly could not feel that Mehitabel would escape." Still, Andrew worshipped his daughter, much as he had worshipped his brother Samuel, who had drowned in the waves off Nauset. With her quirky, wild and disobedient nature, she won the heart of her father in a way that none of his other children had.

The descriptions of Mehitabel's temperament and outlook described by Reynard in *The Narrow Land* are identical to the descriptions of the young and willful Maria Hallett. One wonders if the character of Maria is based on many of the Hallett women. The following description of young Mehitabel certainly mirrors the later stories of Maria Hallett:

> She…was endowed with gay inconsequent laughter, love of sea, star and sky, and of new ideas, and of Old England. When she was a baby she ran away, and now that she was older, danced like a witch on the wet sands…She was mocking, disobedient; yet when she fell and bumped her knee, [her father's] heart contracted as it had not when Ruhama lay ill of fever or when Abigail broke her arm.

Mehitabel was not the only Hallett girl to exhibit the wicked tendencies of her mother. Years before, Andrew's infant daughter, Dorcas, had died while still in her trundle. They say that Satan visited the baby and wrestled for her soul. Actually, Andrew's father-in-law, a drunken man, said so, and he convinced Anne that she, too, had seen her daughter's trundle rise from the dirt floor. Andrew hated his wife's stepfather, and deep down he never believed a word of it. The baby died, but the tavern rumors did not. Now these rumors threatened to tarnish Mehitabel's reputation as well.

Mehitabel said her prayers, but she said them quickly, as if they were songs. Her cadence seemed sacrilegious, and Andrew had to scold her repeatedly. He knew when she had "the look of a cat stalking a bird"

that she was ready to do mischief. Yet he often kept quiet and ignored Mehitabel's ways in order to keep a peaceful household. Still, he prayed silently to God to excuse her youthful behaviors.

Andrew had been told by the schoolmaster, Mr. John Miller, that Mehitabel was very intelligent. Still, Andrew wondered why she couldn't understand religion. He worried that Mather himself would declare his daughter a witch. In fact, according to Reynard, he worried about her soul and her reputation constantly:

> *When he thought of the accusations of witchcraft that were so prevalent, and of Mehitabel's sharp tongue and laughing eyes, he vowed constant vigilance for her sake. He reprimanded Abigail furiously when she called the child a little witch. It would not be long before outsiders said the same words.*

One day, Andrew found Mehitabel, John and Jonathan returning from school in single file. In this section of the story Andrew, Mehitabel and his sons are shown as sympathetic to and even respectful and fond of the area natives. Hallett was known for trading with, employing and spending time with these praying Indians:

> *It occurred to Andrew that his fellow townsmen were not fair to Indians, who should not be expected to understand the customs of Englishmen any more readily than the men of Plymouth Colony understood the rites of savages. Men criticized Andrew for his friendliness toward Indians in a way that made him realize that it was better to keep his opinions to himself.*

Andrew and his children had a good relationship with the natives. Still, when his daughter and sons came along the path that day wearing gifts from the praying Indians, Andrew was stricken with horror and fear. Little Mehitabel wore bright beads, and her brothers held feathers and tools. Later, Mehitabel apologized for wearing the beads after her father struck her fingers four times with the rule. Yet Mehitabel did not really understand what she had done wrong, and her father had a difficult time reasoning with her, for he didn't really understand either.

Andrew need not have worried so much over Mehitabel. She eventually married John Dexter of Sandwich, had a large family of her own and moved to Rhode Island.

Upon Andrew's death, his widow and children inherited his large estate. His sons John and Jonathan inherited most of his property and became, like their father, the wealthiest men in town. John served on various committees. In 1708, he was appointed to a committee to "see that suitable entertainment be made for the ministers and messengers from the churches about to assemble for the ordination of Mr. Greenleaf." Again in 1716, the same year that Maria would have given birth to Bellamy's son, John served on a committee to advocate the building of a meetinghouse for the reason of increased church accommodation. The town voted to build a new and larger meetinghouse by the old one, and the following year, John served on another committee to "place or seat the people in our new meetinghouse as they, or a major part of them, shall see cause."

If Maria was related to this Hallett line, Andrew would have been Maria's grandfather. His son John (the second wealthiest man in Yarmouth) would have been her father. He was born on December 11, 1650, and married Mary Howes in February of either 1681 or 1682. In addition to the jobs listed above, John also served as constable in Yarmouth and as a corporal in King Philip's War. Of his ten children, five were girls and five were boys. Upon his death in 1726, John divided his houses and lands equally among his sons. He left each daughter 150 pounds to be paid by his sons out of their estates. Maria Hallett is believed by some to have been one of those daughters.

Other Hallett men served on committees as well, the most interesting being Isaac Hallett, who in 1774, was appointed to see that no tea be conveyed into the town of Yarmouth. About one hundred years later, in 1885, the town cites the passing of George Hallett, whose death was "greatly lamented." The passage continues: "Mr. George Hallett was long known as an eminent and successful merchant, whose noble heart and public spirit made him extensively honored and greatly respected."

The members of the Hallett line, as illustrated by the records above, were certainly not only wealthy but also active, respected and influential members of Yarmouth and the surrounding areas. But did Maria Hallett, the famed mistress of Black Sam Bellamy, hail from or marry into this line?

Mehitable Brown

B efore we look to the Hallett girls in search of Maria's identity, we
must look at Mehitable Brown. Brown was an Eastham girl who
married into the Hallett family. Mehitable Brown Hallett is an interesting
and elusive woman, as far as genealogy searches go. We cannot be sure
of her birth year, her parentage, her marriage or her death. There also
appear to be two Mehitable Browns living in Eastham at the time. She is,
however, tied to the Hallett family at the very height of Maria's tragedy
and therefore deserves to be included in any research on Maria Hallett.

We know that a Mehitable Brown was born in 1690 to George Brown
and Mehitable Knowles in Eastham, Massachusetts. Many people also
assume that there was another Mehitable Brown, a cousin, born to
William Brown and Susannah Harding sometime between 1690 and
1700. While there are no records to document this Mehitable's birth,
records do indicate that William Brown and Susannah Harding were
married in October 1699 in Eastham, Massachusetts. They had at least
two daughters, Susannah and Lydia, both born after 1700.

William was probably the son of William Brown and Mary Moorcocke
(Murdock). We can only document that he and his wife had the two
daughters shown above. Many would like to link Mehitable Brown to this
family. While this theory is credible, there is no evidence to suggest that
Mehitable Brown is William Brown's daughter.

We do know a lot of information, however, concerning William and Susannah's recorded daughters, Susannah and Lydia. Daughter Susannah, who was born on October 30, 1700, later became the second wife of widower Jonathan Dyer, who was born in Barnstable in 1692. They were married in April 1718 and raised nine children together. She died at age sixty-one in Provincetown. Lydia was born on April 30, 1702, and married an Eastham boy named Simon Newcomb in April 1722. Lydia had two daughters. If naming patterns carry any weight, then it is interesting to note the names that Lydia chose for her children. She named one Susannah, after her sister and mother, and one after herself. You'd think that if she had a sister named Mehitable, she would have named her second daughter after that sister. The example does not prove, though, that she never had a sister named Mehitable. Also consider that she had four sons. She named one after her husband and one after her father. She gave her firstborn son a variation of his father's name, calling him Simeon. Now certainly Lydia liked to keep family names in the family!

By their names and deeds, Lydia's children provide some interesting clues. Through Kenneth Kinkor's research, we know that her sons, Andrew and Simon, sold a parcel of land on Great Island to Samuel Smith in 1743. We know that a tavern existed on the property prior to Smith's Tavern, and it is in that very tavern that Sam Bellamy would have spent his time. Also, according to Kinkor, William Brown was probably the proprietor of the tavern at some point. If so, did his daughter, Lydia, own rights to the property? If so, whether Mehitable was her cousin or sister doesn't really matter; for she would have had ties to the tavern as well.

Now the story gets a little stranger. On March 14, 1715, John Hallett of Yarmouth married Mehitable Brown of Eastham. Though we cannot identify her parents, we know that John married a girl named Mehitable Brown. Of course, Mehitable Brown then became Mehitable Hallett. She was a young girl from Eastham. Records state that she was in her early twenties at the time of her marriage, putting her birth at about 1690–95. The Boston Register gives a birth date of 1690. Yet, within a year of her nuptials to Hallett, Mehitable simply disappears. In just over a year, on August 24, 1716, John Hallett marries another woman,

View from Great Island Tavern, no. 2. *Photo by the author.*

Thankful Thacher. They were joined in marriage by Peter Thacher. In fact, according to Yarmouth vital records, John and Thankful's child, Mary, was the second person to be baptized in the new meetinghouse in 1717. We have multiple records to substantiate their marriage, but we don't know what happened to Mehitable.

It is certainly possible that Mehitable could have died soon after marrying John. Given the time frame, she probably died in childbirth. The problem is that there is no record of her death or her child's death. Where did she go? Certainly she went somewhere, for her husband quickly remarried. Why, if she indeed survived, was her marriage dissolved? And what, if anything, does she have to do with Maria Hallett?

Now we can begin to put some of the pieces of the puzzle together. According to legend, Maria Hallett was from Eastham, and she was born between 1690 and 1700. Mehitable was also from Eastham and was born during the same time frame. Maria's surname was Hallett, and Mehitable's married name was Hallett. Maria Hallett had a tryst with Samuel Bellamy in 1715 and was stoned out of town in 1716. Mehitable was married in 1715 and disappeared from town in 1716.

Mehitable's husband, John, was a sailor at the time they were married. He later became sheriff of Yarmouth. Could it be that while John was out at sea, Mehitable met Bellamy and had an affair with the Englishman? It's entirely possible, especially if her family was connected to the Great Island Tavern. Also, if she were indeed pregnant with Bellamy's child, and John found out, he would have had good reason to dissolve their marriage and choose a new wife.

There's one more striking indication that this Mehitable Hallett might have been the Maria Hallett of yore. When Maria hid her child from the townspeople, she placed him in John Knowles's barn. Legend states that John Knowles was her uncle. Indeed, the Knowleses and the Browns were related. George Brown's wife, Mehitable, was the daughter of Richard and Ruth Knowles, which would have made her Mehitable's aunt or mother.

To add even more mystery to the girl named Mehitable Brown, we can even tie her to the Salem witch trials. A third Mehitable Brown was born in Salem in 1698. Though she was born after the trials, her mother was none other than Hannah Putman, of the infamous Putnam family who were so vocal and active during the witch hysteria.

True, Mehitable carries a different first name than Maria, but there are no Maria Halletts on record in Eastham at that time; therefore, Goody Hallett's original name could very well have been Mehitable. And while the connection between these two women is only theoretical, they certainly seemed to travel in the same circles at the same time. One thing is for sure: mystery and intrigue surround the lives of both these women, historical or not.

CHAPTER 14

The Single Ladies

There was more than one available Hallett girl living in the lands from Yarmouth to Provincetown when Sam Bellamy first visited the peninsula in 1714. The Halletts, as shown in previous chapters, were a well-established family deeply rooted in the ancestry of the Cape.

John and Mary (or Mercy) Hallett of Yarmouth had four eligible daughters: Thankful, Hannah, Mercy and Mary. Their daughter, Hope, would have only been about ten years old when Bellamy came to the Cape. Elizabeth and Abigail Hallett, daughters of Jonathan and Abigail Hallett, would have also been eligible, though Elizabeth was married in the fall of 1714 to Paul Crowell. Their older sister, Mehitable, was already married as early as 1703 to Edward Sturges. If we look at the following young women—Abigail, Thankful, Hannah, Mercy and Mary—we can narrow down the search for the Maria Hallett of folklore.

As Elizabeth Hallett was married by 1714, I want to concentrate on her sister Abigail instead. Abigail was seventeen years old when Bellamy visited the area. Certainly, she was the correct age to have been the legendary Maria. The problem with Abigail is that her life is well documented. While Goody Hallett was haunting the shores of Wellfleet, Abigail was busy raising at least nine children—not in Yarmouth, but in Harwich. She and her husband, Hatsuld Freeman, moved there after their marriage in 1719. She and her husband lived long—he into

his eighty-second year and she into her ninety-eighth! She was a well-respected woman with a lengthy marriage and a brood of offspring born in a different town. Abigail could not have been a childless spinster who had been stoned out of town, for legend states that Maria lived alone in a hut on the dunes.

Abigail's cousins prove a little better suited to the legend. As stated previously, their father, John Hallett, son of Andrew Hallett, was the second-wealthiest man in Yarmouth, second only to his brother Jonathan. He served in various public posts, including constable. Maria Hallett was said to come from well-to-do farmers, and both Hallett families fit the latter description. John's oldest daughter, Thankful, was thirty-three years old when Bellamy came to Cape Cod. It is not likely, therefore, that Bellamy would have been taken with this unmarried older woman, although it is possible. The versions of the legend, however, all put Maria in her teens, and Thankful would have been double her age. Thankful did eventually marry. Two years after the *Whydah* sunk, in December 1719, she became the second wife of Joseph Bassett, and they had four children. She died in August 1736 at fifty-four years of age.

Her younger sister, Hannah, was born in 1689. In 1715, twenty-six-year-old Hannah would have been about Bellamy's age; therefore, a union between them is far more likely. In fact, Hannah remains single until 1728, over ten years after the *Whydah* found its watery grave. Her intentions of marriage to Ebenezer Hallett, her cousin, were published in May, and they were married in June of that year. She was his second wife. Perhaps she had a tryst with Bellamy prior to her marriage. Still, she eventually married and did not live alone like Maria.

Hannah's sister, Mercy, would have been the correct age, for she was born in 1701 and would have been fourteen years old upon meeting Bellamy. By all accounts, Mercy never married nor had any children. She died relatively young, at age forty-six, in November 1747. There are no anecdotes about her life or her relationships with her family, though she does have a headstone inscription in the Ancient Cemetery in Yarmouth. Mercy poses an interesting puzzle. Her name is close, her age is right and she never marries, yet we do not have enough information on her—therefore her connection to Maria Hallett is simply not strong enough.

The most promising lead of all comes from Mercy's sister, Mary Hallett. No one can quite agree on the year in which she was born, so I am basing her age on her cemetery inscription (which may not be correct). At any rate, she was born about 1693 and would have been twenty-two years old when she met Bellamy. While her age does not match the legend exactly (and some researchers give her a later birth date, I assume, so that she fits Maria's purported age), Bellamy certainly could have been enchanted by a twenty-two-year-old woman. He was older than that at the time. Her name, Mary, is also promising. Certainly, she could have gone by the name Maria, as it is a common nickname for Mary. Her name alone is a major piece of the puzzle. Still, names and ages do not prove enough evidence to make a secure link between the two women. But there is more.

Like her sister Mercy, Mary remained single for the duration of her life. Also like Mercy, she retained close ties with her family. If her brother, John Hallett, was indeed tied into the Great Island Tavern, Mary and even Mercy would have spent time there. There is little doubt that their paths would have crossed with Bellamy's. In addition, Israel Cole, whose

Mary Hallett's signature. *Barnstable County Probate Court.*

brothers owned land on which the tavern later stood, was probably connected through marriage to both Bellamy and the Halletts, though we do not have definitive proof of the connection. Regardless, Bellamy spent much of his time on Great Island, and the Halletts seem to have a connection to the spot as well.

While we have no real records to provide the details of Mary's day-to-day life, we know that she lived only a few years longer than Mercy. Mary died in April 1751, decades after Bellamy drowned in April 1717. She certainly had time to establish herself on the dunes and build a dark

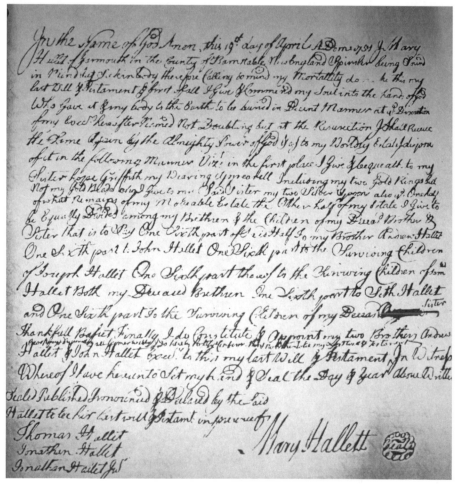

Mary Hallett's will. *Barnstable County Probate Court.*

Inventory of Mary Hallett's will. *Barnstable County Probate Court.*

reputation. She is no different than her sister, Mercy, who could have done the same. Yet, in addition to her name, Mary boasts one other tie to Maria Hallett that Mercy does not.

Before Mary died, she created a will, which was not uncommon in those days; however, her will provides us with a final and interesting clue in our Maria Hallett case. Kenneth Kinkor, historian at the Whydah Museum in Provincetown, was the first to discover her will and make the connection to Maria Hallett. The will is written in the style of the day, mentions many members of Mary's family and is witnessed by her brother John. Mary is generous with her relatives; however, she keeps one important item for herself—a necklace of gold beads (an asterisk indicates illegible section; emphasis added):

> *In the name of God Amen, this 19ᵗʰ day of April Ano Domini 1751, I, Mary Hallett of Yarmouth in the county of Barnstable New England…* [*]*…being sound in mind but sick in body therefore calling to mind my mortality do make this my last will and testament. First of all I give and commend my soul into the hands of God who gave it and my body*

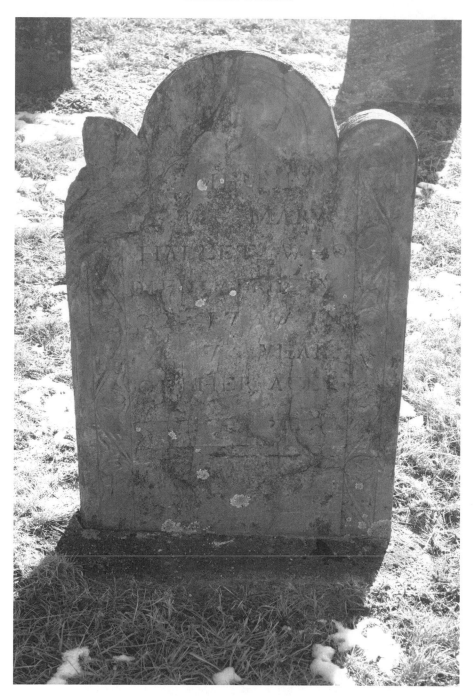

Mary Hallett's gravestone. *Photo by the author.*

to the earth to be buried in decent manner at the discretion of my... [*]...*hereafter named not doubting but at the resurrection I shall receive the same and join by the Almighty power of God...In the first place, I give and bequeath to my sister, Hope Griffith, my wearing appearell,* including two gold rings but not my gold beads. *I give to my said sister my two silver spoons and one half of what remains of my moveable estate. The other half of my estate I give to be equally divided among my brethren and the children of my deceased brother and sister, that is to say one sixth part of half to my brother Andrew Hallett, one sixth part to John Hallett, one sixth part to the surviving children of Joseph Hallett, one sixth part to the surviving children of my deceased sister, Thankful Bassett. Finally I do constitute and appoint my two brothers, Andrew Hallett and John Hallett Exec. to this my last will and testament in witness whereof I have here unto set my hand and seal the day and year above written. Signed sealed published...and declared by the said Mary Hallett to be her last will and testament. (Witnessed by Thomas Hallett, Jonathan Hallett and Jonathan Hallett, Jr.)*

Mary's estate was divided in August 1751. It included wearing apparel, money, plates, bed, bedding, books, table linen, bottles, pillows, lumber, pewter, chairs, a cupboard and a looking glass. She also had outstanding notes and bonds. Her estate was worth £76.13.

First of all, the fact that Mary chose to be buried in these beads means that they were sentimental to her, for like a good Puritan woman she gave all her other worldly possessions away. Secondly, where did Mary get a necklace of golden beads? Though her family was well-to-do, I have studied her father's will. Neither of her parents left her golden beads. She was never married, and so we know that her husband did not give them to her; therefore, perhaps she earned them from an admirer. Again, he would have to be a pretty wealthy man to furnish his fancy with golden beads. Perhaps they came from Bellamy's treasure, and this link of beads is the strongest link of all to the possibility that Maria Hallett, in fact, actually existed as one Mary Hallett of Yarmouth.

Myths, Legends and Theories

The story of Sam Bellamy and Maria Hallett has survived for almost three hundred years in various forms. On rainy and windy evenings, Cape families gathered around their hearths and told of Black Bellamy and the cries of his mistress as she shrieked her vengeance into the night skies.

In the early 1900s, a slew of these tales were published by collectors of Cape Cod folklore. Shebnah Rich, Otis Amos, Michael Fitzgerald, Jeremiah Digges, Eleanor Early and Elizabeth Reynard, among others, transcribed portions of the Bellamy/Hallett legend. When these oral tales were transcribed, a new generation of children came to know Goody Hallett and Samuel Bellamy. And when Barry Clifford discovered the watery grave of the *Whydah* in 1984, the first generation of children enjoyed actual evidence to document the old legend.

Today, Sam and Maria's tale is preserved through artifacts at the Whydah Museum and through storytellers like Patrick Fitzhugh. The tragic relationship has been staged in Cape playhouses, investigated in documentaries and salvaged in the seas off Marconi. The public is fascinated by their love story, and why not? Beautiful girls, witches, pirates, murder and treasure make for exciting folklore.

When I first heard the marvelous tale of their doomed love, I was just as fascinated as those who had heard it before me. I visited the Whydah

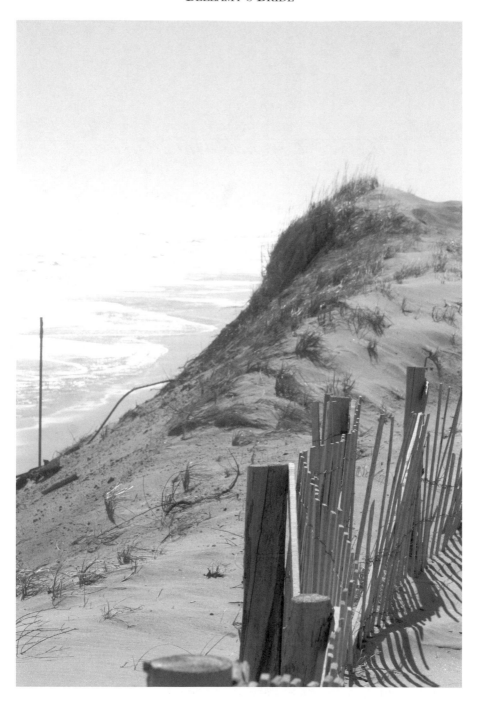

The bluff at Wellfleet. *Photo by the author.*

Museum, viewed treasure and read stories. But it was not the cannons or coins that really intrigued me; it was the young Eastham girl named Maria. I searched for references to her in every tale. To me, she was and is the driving force of the entire legend. I wondered how many people had actually researched genealogical records to see if Maria had, in fact, existed.

There is no doubt that portions of the story originate in myth. The biblical and mythological connections are obvious. Sam and Maria's meeting comes right out of Genesis. The apple tree under which Maria stands is like the tree of knowledge of good and evil in the Garden of Eden. Like Eve, Maria holds the apple. Once she and Bellamy consummate their relationship in the orchard, they cement their doom. Like Adam and Eve, they are cast out: Sam to the sea, and Maria to her hut.

The apple appears in Greek mythology, as well. Zeus holds a banquet to celebrate the marriage of Peleus and Thetis, but he does not invite Eris, the goddess of discord. As revenge, she inscribes a golden apple with the phrase "for the fairest" and throws it into the hall. Of course, every goddess wants to believe that the apple is meant for her. Paris must judge between the goddesses, and each offers him a tempting reason to choose her as the fairest. Aphrodite, however, provides the best option of all. She will give Helen, the most beautiful woman in the world, to Paris. Helen is already married, of course, and so begins the Trojan War. Lesson from Greek mythology and Cape Cod folklore: beautiful women and apples lead to tragedy.

Regardless of the fact that Maria's story is certainly grounded in myth, there is no doubt that there was a girl who also inspired the legend. Before I began to write this book, I had already come to one conclusion concerning the historical legitimacy of Maria Hallett: the legend must have been based on a real Cape Cod woman. Though I am a romantic by nature, and I love a good story as well as the next person, my conclusion is not a sentimental one. There are three players at the heart of this tale: Samuel Bellamy, Maria Hallett and the *Whydah* galley.

Through English and colonial records, as well as eyewitness accounts, we know that Samuel Bellamy was a historical figure. While some of his exploits may have been hyperbolized, the facts that a man named Samuel Bellamy was born in England, spent time on Cape Cod and turned pirate are all well documented. His associates—Paulsgrave Williams, Israel Cole and Benjamin Hornigold, among others—are also real historical

figures. The Spanish Plate Fleet disaster is described in numerous records. Bellamy's death, though not verified, can be reasonably assumed to have occurred with scores of other pirates on April 26, 1717. The stories scribed by Fitzgerald and Reynard follow historical accounts of the people and places in question so closely that the undocumented sections of their tales must be grounded in some fact.

The *Whydah*, too, can be traced to its origins. It was an English ship named for the African slave trading port, Ouidah. It was built about 1715 and captained by Lawrence Prince. The surviving pirates gave accounts of the silver, gold and cannons aboard the ship. While the *Whydah*'s destruction was detailed in newspapers of the day, people gave up on finding its treasure long ago—all except one man, that is.

When Barry Clifford first began to excavate the wreck site and bring artifacts to the surface, many skeptics refused to believe that the items were in fact from the *Whydah*. Clifford, a firm believer in the legend, silenced all naysayers when he discovered the bell of the great ship, which read: "The Whydah Gally, 1716." Since then, he has documented hordes of treasure, artifacts and even pirate bones.

So, we can say with certainty that two of the three "actors" in this tragedy existed in much the same manner in which the legends describe them. And what of the third? What of the woman who inspired the pirate Sam Bellamy?

After my research, I have also come to believe that Maria could have been based on more than one Hallett woman. One of the most consistent figures in the legends is that of the spinster, Goody Hallett. Jeremiah Digges speaks of her as an old woman to whom everyone in town brought their wool, even if they feared her. Digges supposes that they feared her simply because she lived alone and kept to herself. From what we know about Puritan New England, he was probably right. Cape Codders were certainly intrigued by Bellamy's pirate plunder, and when the mass of the loot disappeared into the shifting tides, why not blame the little old woman who lived by the very site of the wreckage—the little old woman who was already said to command the winds and the seas?

I suspect that the story of Bellamy and Maria's first encounter came later and out of necessity. Cape Codders wondered why Bellamy would return to their shores. The captain of the snow feared that he might attack

Provincetown, but that doesn't seem likely. As the residents surmised, there had to be another reason that the pirate would risk the dangerous bars of the Cape. Why would he make such a foolish decision when he could have traveled safely to Maine, where he had promised to meet up with Williams? Why does any man make foolish decisions? Because of a woman, of course! So Bellamy must have returned for a woman. And here, the image of a younger Hallett—one beautiful enough to capture the heart of a pirate prince—emerges.

Whether it was a different girl altogether who stole Bellamy's heart while Goody Hallet stole his treasure, who can say? She could have been the same woman, but she seems to age rather quickly after Bellamy's demise. While her deterioration makes for marvelous fireside tales, it is unlikely that such a beautiful girl would wither so rapidly. In reality, the townspeople may have hastened her hideous transformation. Perhaps the beautiful Maria Hallett aged naturally, and the people simply focused on her as young and then old to fit the needs of their tales.

I must admit that while I searched records and graveyards, I secretly hoped that I would not find Maria Hallett. And I imagine that you are wondering why I would even write the book if I really never wanted to find the girl. The answer lies in the reason her story intrigued me in the first place. My brain tells me that an old woman named Goody Hallett existed and that she was probably a strange old spinster who scared the children of Yarmouth with her odd behavior. She scared them enough that they blamed her for taking Bellamy's treasure and knit her name forever with that infamous pirate.

My heart, however, tells me that there are too many portions of this story that are so specific and so often repeated that they must be based in truth. That truth must add up to more than an elderly woman who spun beautiful cloth in her lonely hut. That truth involves a frightened young girl who fell in love and gave birth to a child. She endured the death of her newborn, the bars of the prison and the scorn of her neighbors. She held her head high as they stoned her out of town, and she battled the elements in her makeshift hut. She tended to the drowning Bellamy and knew the secrets of his treasure. And finally, after a life of adversity and hardship, she was buried in golden beads. That is the girl I will continue to search for. That is Maria Hallett.

Bibliography

Botkin, Benjamin Albert. *A Treasury of New England Folklore: Stories, Ballads and Traditions*. New York: Crown, 1947.

Burrage, Henry Sweetser, and Albert Roscoe Stubbs. *Genealogical and Family History of the State of Maine*. Vol. 4. New York: Lewis Historical Publishing Company, 1909.

Clifford, Barry. *Expedition Whydah*. New York: Cliff Street Books, 1999.

Coogan, Jim. *Cape Cod Companion: The History and Mystery of Old Cape Cod*. Dennis, MA: Harvest Home Books, 1999.

Daniels, Clarence B. "That Was the Island That Was." *Cape Cod Compass*, 1964.

Digges, Jeremiah. *Cape Cod Pilot*. Provincetown, MA: Modern Pilgrim Press, 1937.

Drake, Samuel G., ed. *New England Historical and Genealogical Register*. Vol. 9. Boston: Samuel G. Drake, 1855.

Early, Eleanor. *And This Is Cape Cod*. Cambridge, MA: Houghton Mifflin Company, 1936.

Fitzgerald, Michael. *1812: A Tale of Cape Cod*. Yarmouthport, MA: Register Press, 1912.

Fitzhugh, Patrick. *The Legend of the Whydah*. CD recording, 2004.

Franklin, Benjamin. "Polly Baker's Speech." *General Advertiser*, April 1747.

Freeman, Frederick. *The History of Cape Cod: The Annals of the Thirteen Towns of Barnstable County*. Vol. 2. Boston, MA: George C. Rand & Avery, 1862.

Henigman, Laura. *Coming into Communion: Pastoral Dialogues in Colonial New England*. New York: State University of New York Press, 1999.

Hutchinson, Thomas. *The History of the Colony and Province of Massachusetts Bay*. Cambridge, MA: Harvard University Press, 1936.

Kinkor, Kenneth. "The Search for the Whydah Pirates." Essay received through private correspondence.

Knowles, Oliver. "Goody Hallett's Treasure: A Legend of the Pirate Bellamy." *Cape Cod Beacon*, March 1937.

Lawson, Evelyn. *Yesterday's Cape Cod*. Miami, FL: E.A. Seemann Publishing, 1975.

Mather, Cotton. "The Wonders of the Invisible World." In *Narratives of the Witchcraft Cases: 1648–1706*, edited by George Lincoln Burr. N.p., 1693.

Otis, Amos. *Genealogical Notes of Barnstable Families*. Edited by C.F. Swift. Barnstable, MA: Patriot Press, 1890.

Perley, Sidney. *Historic Storms of New England*. Salem, MA: Salem Press, 1891.

Pratt, Enoch, Reverend. *A Comprehensive History, Ecclesiastical and Civil, of Eastham, Wellfleet and Orleans*. Yarmouth, MA: W.S. Fisher and Company, 1844.

Rich, Shebnah. *Truro–Cape Cod: Landmarks and Seamarks*. Boston, MA: D. Lothrop and Company, 1883.

Rogers, Mary Bangs. *Old Cape Cod: The Land, the Men, the Sea*. Cambridge, MA: Riverside Press, 1931.

Simmons, Frederick Johnson. *A Few Descendants of William Brown of Eastham, Mass, Cape Cod*. Haverhill, MA: Pentucket Press, 1929.

Skinner, Charles M. *Myths and Legends of Our Own Land*. Philadelphia, PA: J.B. Lippincott Company, 1896.

Spence, Homan H. "A Story of Murder in Wellfleet." *Cape Codder*, February 1980.

Swift, Charles F. *Cape Cod, the Right Arm of Massachusetts: A Historical Narrative*. Yarmouth, MA: Register Publishing Company, 1897.

———. *History of Old Yarmouth*. Yarmouth Port, MA: C.F. Swift and Son, 1884.

Woodard, Colin. *The Republic of Pirates: Being the True and Surprising Story of the Caribbean Pirates and the Man Who Brought Them Down*. Orlando, FL: Houghton Mifflin Harcourt, 2007.

About the Author

Kathleen Brunelle was born and raised on Cape Cod. She attended the University of Massachusetts–Dartmouth, where she earned bachelor's degrees in literature and writing and her master's degree in English. Her work has appeared in *Cape Cod View*, *Art Times*, *Moxie* and the *Shop*. She currently teaches English at Old Rochester Regional High School in Mattapoisett, Massachusetts. She lives with her husband, Robert, their son, Baylen, and their two golden retrievers.

Visit us at
www.historypress.net